P9-CRX-942

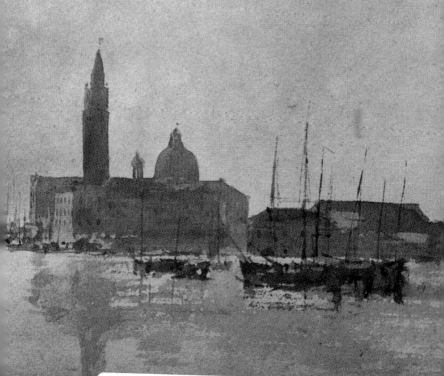

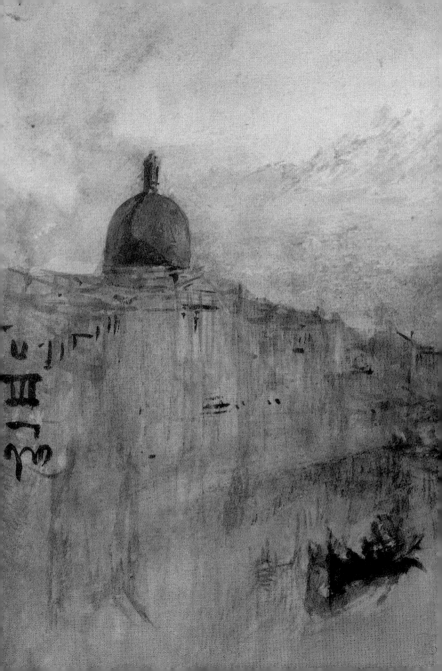

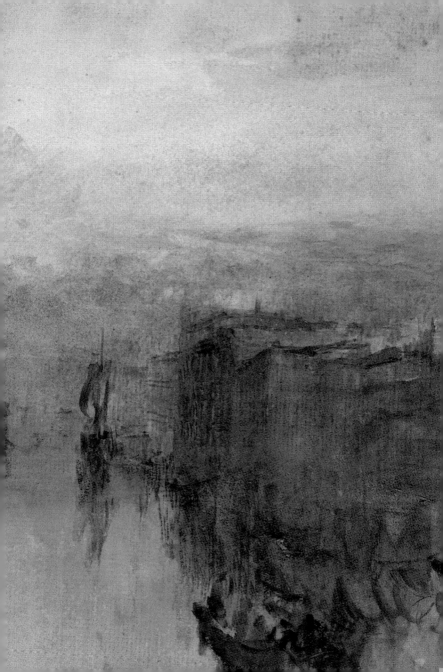

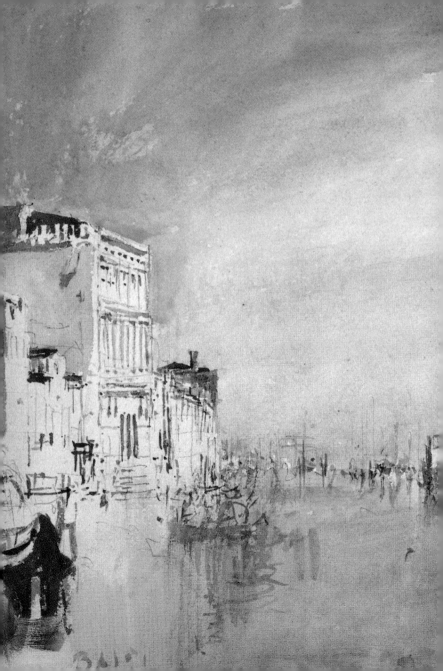

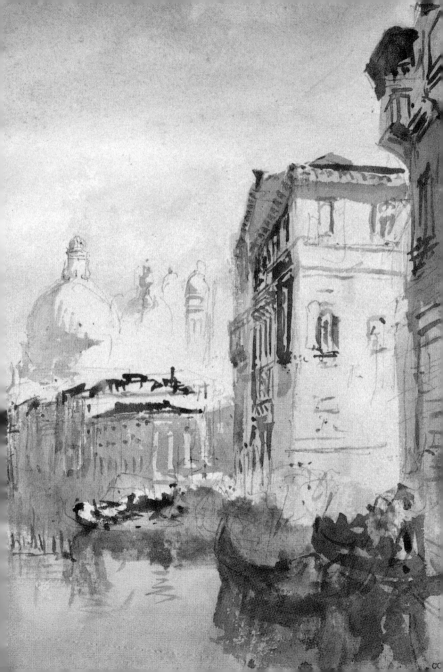

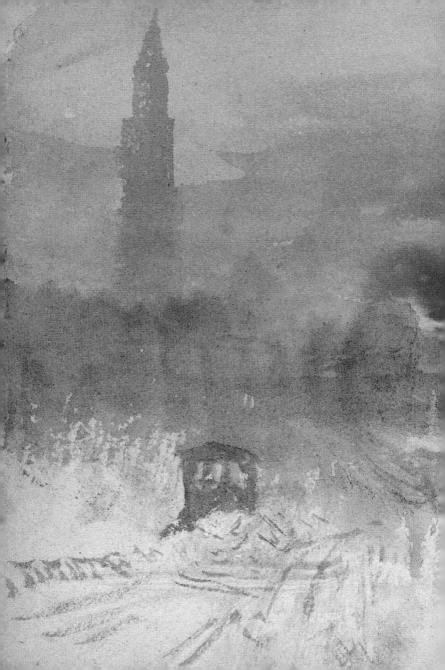

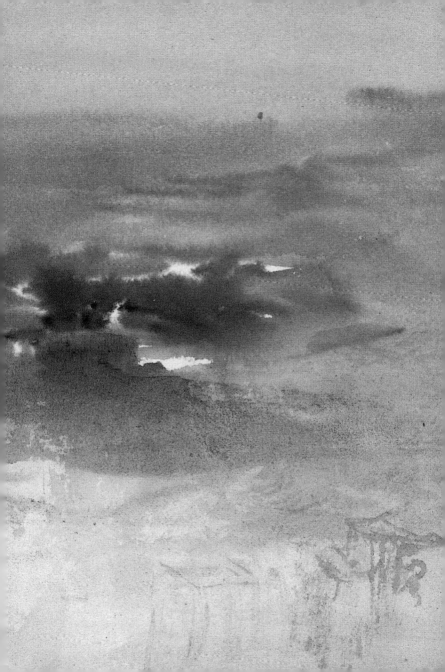

CONTENTS

TURNER
LIFE AND LANDSCAPE

Olivier Meslay

DISCOVERIES®
HARRY N. ABRAMS, INC., PUBLISHERS

Turner was a precocious, determined and highly motivated child. He coloured engravings in exchange for a few shillings and began drawing in earnest at a very early age. At fourteen, he was admitted to the Royal Academy Schools, where he soon moved from watercolour landscapes to historical paintings. Within a few years he built up a reputation, and at twenty-six he was elected a full member of the Royal Academy.

CHAPTER 1

A CLASSICAL EDUCATION

On 31 December 1799, the twenty-four-year-old Turner received his diploma (above) as an Associate Member of the Royal Academy, a position to which he had been elected a month earlier, becoming the youngest Associate Member in Academy history. It was an honour that some artists never achieved in their lives, and set the seal on Turner's meteoric rise. Opposite, a self-portrait (*c*. 1799) shows a studied elegance that he often seemed to lack.

In the hurly-burly of Covent Garden

In 1775, London's Covent Garden was packed with theatres, and David Garrick, the most celebrated actor of the age, dominated Drury Lane. William Turner had a barber's shop near St Paul's Church, which overlooked the square. Turner senior was industrious, genial and talkative, and his shop was located in the busiest district of the city, at its artistic and commercial heart, and only a short distance from the city's legal centre. He was consequently never short of business.

It was in this lively environment that J. M. W. Turner spent the greater part of his childhood. Born on 23 April 1775, the young Turner was christened at St Paul's Church. On his father's side, the family were mainly craftsmen and modest employees. His mother's family had been butchers since the end of the 17th century. They came into some money at the beginning of the 18th century, acquired land and contracted a number of alliances with the clergy and small landowners with links to the gentry. Three years after the birth of their son Joseph Mallord William (the Christian names of his mother's brother), the Turners had a daughter, Mary Ann, who died in 1783 at the age of four.

Mary Turner's natural tendency to melancholy was exacerbated by the death of her daughter. Despite the difficulties caused by his mother's mental health and her inability to assume the full weight of her family responsibilities, and despite his sister's death, Turner seems to have grown up in a warm and loving atmosphere. In 1785, when his mother's condition deteriorated, the young William, as he was known, was sent to live with the maternal uncle he was named after, in Brentford in Middlesex. It was probably there that he began producing his first sketches, an activity he took up

Left, a presumed portrait of Turner's mother Mary, c. 1793. Mary Turner's life was marred by tragedy. She was not mentally robust and found London life constraining. The death of her daughter appears to have triggered a severe depression and from 1790 Mary Turner spent increasingly lengthy periods as an inmate of one or other of London's psychiatric hospitals. In 1799, she was confined to St Luke's Hospital for Lunatics in Old Street. A year later, she became an inmate of the famous Bethlehem Hospital, and in 1801, believed to be incurable, she was moved to a private asylum, where she died on 15 April 1804. According to Walter Thornbury, Turner's first biographer, the artist had the same aquiline nose as his mother, and the same blue eyes. In 1832, Turner erected a monument to the memory of his parents in St Paul's Church, Covent Garden (opposite), the parish church of his childhood. Above, the church register showing Turner's baptism, 14 May 1775.

Thomas Henry by Elizabeth his Wife
...iam Son of William Turner by Mary his Wife
...l Son of Philip Prior by Charlotta his Wife

with growing determination and obvious talent. The drawings found their way into the window of his father's London shop, where they were displayed with pride.

The following year, Turner was sent to Margate in Kent. It was in the same year, 1786, that he appears to have begun working from the old masters (clearly supported at the time by his father), colouring prints for the engraver John Raphael Smith and the publisher Paul Colnaghi, both of whom were established in Covent Garden.

An interest in architecture

The focus of his interest soon shifted, however, to architecture and later landscape. It was at this point,

At the end of the 18th century, Covent Garden (below) was the epicentre of London life, a district of market stalls and theatres and a meeting place for fashionable society. The barber's shop owned by Turner's father was located a few streets to the left of St Paul's Church, which can be seen, with its portico, on the far side of the square.

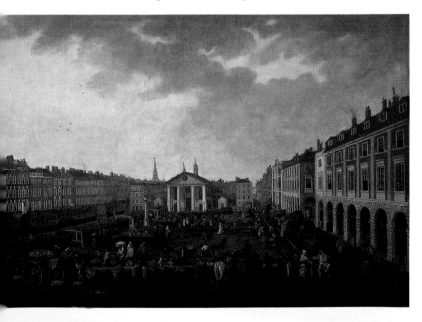

probably with the encouragement from his father, that he committed himself to a career as an artist. His first employment as a draughtsman (when he was barely fourteen) was with the architect Thomas Hardwick (1752–1829). He went on to study with Thomas Malton (1748–1804), a landscape artist particularly interested in architecture whom Turner was always to regard as his 'true master'.

Topographical landscapes were an unsurprising choice for an artist at this time. Although it was a route that artists elsewhere in Europe would probably have considered strange, and rather marginalized, in Britain landscape painting was viewed in a wholly different light. Imported from the Netherlands by artists such as Jan Siberechts at the end of the 17th century, the topographical approach – with its emphasis on precision and careful calculations – was immensely successful in Britain. As part of their concern to commemorate things – people, animals, house interiors – and preserve them for posterity, British artists were also eager to perpetuate the memory of landscapes and so depicted the surroundings of towns and great estates with a degree

In 1791, the date of this self-portrait (top left), Turner was sixteen and a pupil at the Royal Academy Schools, whose registers of attendance show him to have been a conscientious student, dutifully attending his various classes. In addition to his studies, he had already done some travelling, to Bristol to visit a friend

of his father, and also to Wales, and he was regularly showing watercolours. Any clumsiness in his early drawings (left, *A Street in Margate, Looking Down to the Harbour*, c. 1784) soon vanished after his Academy training. Even in this modest watercolour, the young Turner pays careful attention to the roof details and the design of the windows.

of detail worthy of a legal document. It would be a mistake, however, to assume that their approach was in any way dry or cold. In fact, what essentially characterized this type of painting was a fidelity to, and respect for, its subject matter. Turner could have found no better training ground for his artistic talents, and

Below, the plaster casts room at the Royal Academy. The Academy provided Turner with a complete education, following the piecemeal instruction he had received until then.

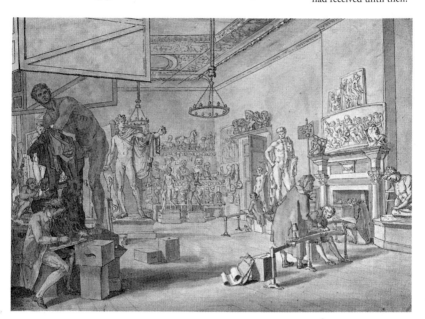

the topographical landscape, with its concern for truth, was to remain an important part of his artistic practice.

At the Royal Academy Schools

The French-born landscape painter John Francis Rigaud, then established in London, encouraged the young Turner to apply for a place at the Royal Academy Schools. On 11 December 1789, Turner was admitted as a pupil of the Schools after successfully completing an examination in which he was required to produce drawings from casts of antique sculpture. The Royal Academy, long awaited by British artists, had only been in existence some twenty years. Created in 1768, it was

It boasted a remarkable collection of casts of antique sculpture and introduced the young artist to the key elements of classical culture. At the end of March 1793, he received the Society of Arts' silver palette in recognition of his achievements as a landscape painter. Opposite, centre, *Study of the Belvedere Antinous, c. 1793.*

Left, *The River Avon from Cook's Folly*, from the *Bristol and Malmesbury* sketchbook. Turner was always looking out for new subjects to paint, and the quest for 'views' remained a constant and integral part of his art. Architectural studies, like the one below, with their minute attention to detail, were followed by more varied approaches to landscape. Watercolours began to focus on the atmosphere inherent in a particular view, and water and trees were exaggerated in a new type of spatial representation.

inspired by the Académie Royale de Peinture et de Sculpture in France, but operated in a less rigid and less hierarchical fashion, offering places to women as well as men and also accepting foreigners.

Turner attended classes until 1793, initially drawing from casts of antique sculpture and later from life models. At the same time, he showed watercolours at the annual summer exhibition – mainly topographical views, landscapes and paintings of famous architectural landmarks, such as *The Archbishop's Palace, Lambeth*, which was shown in 1790. That same year, Turner attended the final lecture given by Sir Joshua Reynolds, the Royal Academy's first president, whose theories were to have a major influence on the young artist. Turner rapidly assimilated Reynolds' ideas about the hierarchy of genres, the imitation of the old masters, the intellectual approach to the arts and the relationship between painting and poetry, and his admiration for Reynolds was apparent both in his own Academy lectures on perspective in 1811, and in his wish (which was granted) to be buried alongside Reynolds in St Paul's Cathedral.

In 1791, Turner went on the first of the summer trips which took him, successively, to Bristol, then to Wales, Kent and Sussex, the Midlands, the Isle of Wight and the Lake District. During these journeys – which compensated for the impossibility of travelling further

afield, through a Europe ravaged by war – Turner either drew or painted (watercolours) from nature, visited famous sites and studied the works on view in Britain's great houses. As his experience increased, he was even commissioned by a publisher to produce several dozen views of the River Avon, which were subsequently published in *Copper-Plate Magazine* in 1794.

Dr Thomas Monro

The previous year, Turner had met an important figure on the London artistic scene, Dr Thomas Monro (1759–1833). A physician specializing in mental disorders, Monro was a wealthy collector and amateur artist, and exercised considerable influence over a whole generation of painters, setting up what might be described as a private academy, the purpose of which was to bring together young artists in the evening and encourage them to copy works in his collection. This included Dutch, Flemish and Italian paintings, but

The first watercolours that Turner showed at the Royal Academy (below, the title page from the 1790 catalogue) demonstrated an approach that favoured precision rather than atmosphere. His perspective technique was skilful, but it was still academic. In *The Archbishop's Palace, Lambeth* (below left), shown in 1790, nothing is left to chance and the outline of the building is absolutely

faithful to reality. The figures cleverly punctuate the expanse of the street, which might otherwise seem too wide, and a tree on the left and the corner of a building on the right serve to frame the scene and to direct our gaze inwards.

above all a remarkable group of English watercolours, notably by Edward Dayes (1763–1804), Michael Angelo Rooker (1743–1801), Thomas Hearne (1744–1817) and John Robert Cozens (1752–97). The artists received a fixed price for each copy they produced – and a supper of oysters into the bargain.

Left, a sketch of Turner by Thomas Munro, c. 1795. Turner worked in the evenings in Dr Monro's rooms overlooking the Thames. Monro's young protégés sat at double desks, facing one another, sharing the same light and painting from the same models. Monro's collection of contemporary drawings, which Joseph Farington, a great chronicler of artistic life of the time, described as the largest he had ever seen, included more than 90 watercolours in the dining room and more than 120 in the drawing room. Later, Monro began to stick some drawings straight on to the walls of his country house, like wallpaper. Below, a late 18th-century watercolour set.

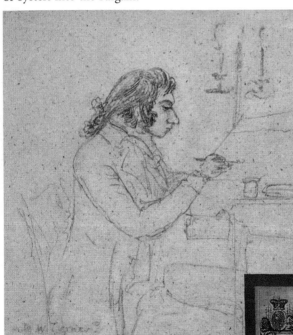

It was at Dr Monro's establishment, in the company of Thomas Girtin (1775–1802), his exact contemporary, that Turner discovered the work of John Robert Cozens, whose technique and subject matter – the Alps and Italy – profoundly influenced him. His meeting with Girtin, whose line drawings were unrivalled, proved equally influential. The painter and chronicler Joseph Farington (1747–1821) reports that the two artists worked together, Girtin

drawing the outlines and Turner applying the colour wash. Turner bought back a number of these collaborative works (now in the Tate Britain) when Dr Monro's collections were sold in 1833. They demonstrate the close relationship that grew up between the two young painters at those regular Friday evening sessions from 1794 to 1797. Girtin died at the age of twenty-seven and Turner retained a deep admiration for his talented companion.

Watercolour: his medium of choice

The first medium in which Turner chose to express himself – and to which he owed his rapid success – was watercolour. For the previous quarter of a century, or thereabouts, Britain had provided the perfect niche for watercolour painting, an increasingly popular medium with British artists, especially landscape painters. The craze for watercolour was accompanied by a number of technical innovations. Up until the 1780s, artists had been obliged to make their own paints – a painstaking

Above, *Florence from the Cascine*, c. 1795–97. Turner's often used a brown wash, sometimes mixed with grey. Using the paper in reserve to create the shape of the trees, he used subtle gradations to suggest the ground, the bushes, the top branches and the sky. This work, which is probably a copy of a watercolour by John Robert Cozens, demonstrates how fast Turner's art was developing. It is notable for the way that it relies on subtle tones and the relationship between light and dark areas to support the illusion of perspective depth.

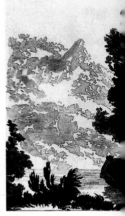

procedure and one that almost required a period of apprenticeship – but a process developed by the brothers William and Thomas Reeves revolutionized the use of watercolour by making it possible to buy ready-made paints. However, it was not until 1832 that William Winsor and H. C. Newton began to make and sell paints in small blocks designed to be carried in boxes.

It was at a time, then, when such aspects of the technique were being fine-tuned that Turner began to devote himself to watercolour painting. Watercolour was the perfect medium for his experiments – one that, for the first time, allowed the artist to capture swiftly the memory of a place or a moment, a stormy sky or a sunset, and to record not merely the contours of a landscape but also its tones, its colours and transparencies. Moreover, the lightness of the material and its ease of transportation made it possible to work in places that had previously been inaccessible.

The masters of the genre

And yet watercolour had long been regarded less as an art form than as a means to an end. Even great founding figures like the Reverend William Gilpin (1724–1804) and Alexander Cozens (c. 1717–86), father of

One of Turner's earliest known drawings (now lost) was a copy of *Dacre Castle*, an engraving by Reverend William Gilpin, teacher, writer, parish vicar and amateur artist. Gilpin's book about English beauty spots (title page, below) served Turner as a reference work during his journeys around England and Wales.

OBSERVATIONS

RELATIVE CHIEFLY TO

PICTURESQUE BEAUT

Made in the YEAR 1772,

On several PARTS of ENGLAND

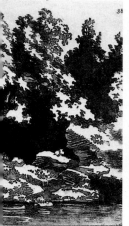
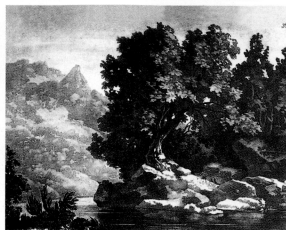

John Robert Cozens, saw it as a interesting exercise rather than as a technique designed to produce finished works of art.

Both Gilpin and Cozens produced monochrome wash drawings, largely free of colour. Gilpin, however, was highly instrumental in establishing the success of the medium through his creation of the 'Picturesque Tour', an illustrated account of a journey based on the beauty of a particular landscape and the possibility of extracting from it a series of appealing scenes. Gilpin's travels, undertaken between 1769 and 1774, were documented and published by his own efforts in 1786, in a celebrated work entitled *Observations Relative Chiefly to Picturesque Beauty, Made in the Year 1772, on Several Parts of England; Particularly the Mountains and Lakes of Cumberland and West Moreland.* Following the aristocratic Italian Grand Tour, an obligatory part of any artistic education, the Picturesque Tour became and remained fashionable. Through his copies from Gilpin, his own travels, and above all his use of watercolour, Turner remained profoundly influenced by this particular approach.

From the 1750s, the other influential artistic figure of the time, Alexander Cozens, encouraged his students to produce drawings from ink blots (either deliberate or accidental) as a way of exercising their creative freedom.

A blot is not a drawing but a collection of coincidental forms that can initiate creation of a drawing.
Alexander Cozens

Above, three etchings produced from ink blots according to Alexander Cozens's method. Since the Renaissance, artists had made use of the artistic potential of accidental blobs of colour, but it was not until Cozens that these happy accidents gained the status of a teaching method. Demonstrating the possibilities inherent in a blot of ink, Cozens broke with academic tradition and loosened the stranglehold of the old masters on the artistic imagination.

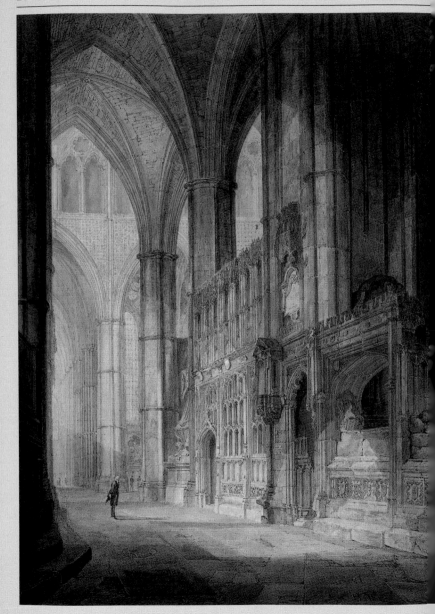

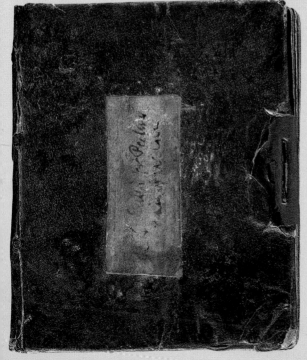

Opposite, *St Erasmus and Bishop Islip's Chapels, Westminster Abbey*, 1796. Turner's large watercolours intended for exhibition purposes were painted in his studio. Carefully composed and often reworked, they were given the same care that he devoted to his oil paintings. Very few of Turner's drawings are still contained in bound books like this one (the *Wilson* sketchbook, left), with its label and brass clip. From the start of his career, the artist took sketchbooks of this type with him on all his travels. He used them mostly for quick sketches, but sometimes painted more elaborate scenes in them (above, *A River with Trees and Buildings against a Sunset Sky, c.* 1796–97).

His teachings, centring on the imagination, were published in 1786, the year of his death, under the title *A New Method of Assisting the Invention in Drawing Original Compositions of Landscape*.

Early success

When Turner showed his first watercolours at the Royal Academy, the technique was attracting interest from a growing public and sales could provoke an atmosphere of frenzy. This watercolour craze even led to the creation of a number of institutions such as the Society of Painters in Water-Colours in 1804, designed to promote better conditions for showing works. Within a few years, Turner's reputation was established; he was comfortably off and confident of his artistic abilities. There were others among his contemporaries who were also hugely successful: among them, John Glover (1767–1849) – regarded for many years as a rival to Turner – whose works sold for extremely high prices and were so popular that demand sometimes exceeded supply.

Having swiftly proved himself as a watercolourist, Turner now felt the need to seal his reputation as an artist by taking the final step and painting in oils. When, in 1796, he presented his first oil painting, *Fishermen at Sea*, for public appraisal, he had already gone through a lengthy preparatory period, widening his experiences and assimilating the many traditions of the genre. His annual travels and his visits to some of London's great houses had allowed him to build up his own

Turner's contre-jour effects, his dazzling yellows, and his seas reflecting the rays of the rising or setting sun, are all variations on themes by Claude Lorrain. In around the same period,

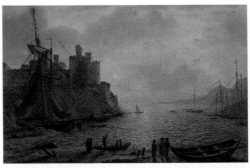

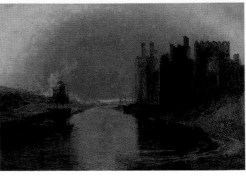

John Glover (*Conway Castle*, top) and Turner (*Caernarvon Castle*, below) attempted to reproduce the same effects while experimenting with the transparencies of watercolour. Glover later gave his landscape art a radically new direction by moving to Tasmania.

remarkable visual and cultural resources. The collections accumulated over the course of almost a century by wealthy British families as a natural consequence of their Grand Tours were generally open to anyone who wished to see them, whether artists or art lovers, and whether they slipped a coin to the staff or came armed with a recommendation. It was primarily in these great houses,

Below, Claude's *Seaport with the Embarkation of the Queen of Sheba*, 1648. Themes from ancient history, magnificent architecture and ruins, and atmospheric

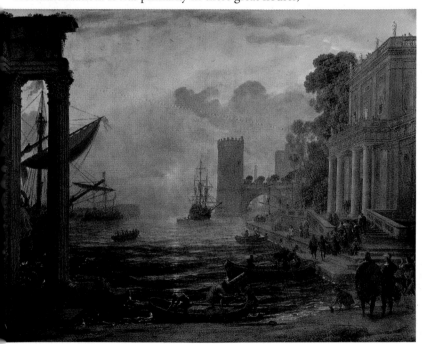

then, that Turner discovered the riches of the European landscape tradition.

Claude's inspiration

His principal model was Claude Lorrain (born Claude Gellée, 1600–82), an artist famous enough to be known by his Christian name alone.

There was nothing unusual in this choice: Claude's all-encompassing idea of beauty – with its key elements of serenity and balance – had been influencing artists

seascapes are among the key elements of Claude's paintings. The magic of his art lies in his ability to capture sunlight in all its dazzling glory. The rules of composition that he established in the mid-17th century became a blueprint for artists for centuries to come.

The fascination exerted by Claude Lorrain on English collectors had less to do with his landscapes – scenes from ancient history bathed in glorious light – than with his capacity for poetic evocation. In *The Enchanted Castle* (left), the artist explored a whole new realm of the imagination. The trees and the castle are enveloped in a haze, and there is a dreamlike lightness about the castle, as if it were suspended above the ground. It was this almost impalpable aspect of Claude's art that Turner most sought to imitate.

since the 17th century, and a genuine passion for the artist was responsible for promoting his style of painting in Britain. Almost two thirds of his painted works and all the drawings from the *Liber Veritatis*, in which Claude recorded all his paintings in sketches, have at one time or another belonged to the collections of Britain's stately homes. Claude was generally regarded as the greatest landscape artist of all time, and his work possessed a

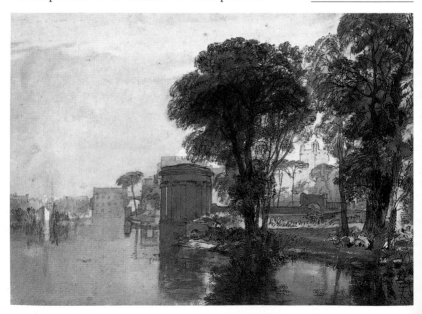

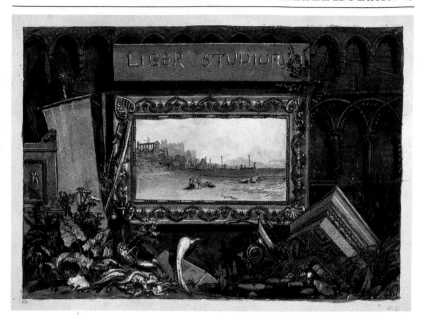

number of different facets. Like Poussin, Claude painted compositions in which buildings from classical antiquity and mythological or historical scenes provide a foreground to a landscape whose atmosphere owes as much to reason as to feeling. As *The Enchanted Castle* (1664) demonstrates, however, he also painted in a style – adored by British collectors – that was altogether more dreamlike.

Claude swiftly assumed a central place in Turner's artistic pantheon. Viewing the Angerstein collection at a young age, Turner is said to have burst into tears at the sight of a harbour view by the painter. In response to the collector's insistent enquiries regarding the cause of his emotion, he apparently replied with great passion: 'Because I shall never be able to paint any thing like that picture.' In 1795, he visited Sir Richard Colt Hoare for the purpose of studying, not just his collection, but also his famous gardens at Stourhead – at the time the most extraordinary attempt to recreate Claude's style of painting in a natural setting. Turner was particularly

It was Turner's friend, William Frederick Wells, who, in 1806, prompted him to publish his *Liber Studiorum,* a catalogue of works on the model of Claude's *Liber Veritatis* (1777). Turner's book was noted for the high quality of its engravings of his works. The parts were issued in series of five plates; the frontispiece (above) was published with the tenth part, in 1812. One hundred engravings were planned, but only seventy-one were actually produced. Opposite below, a design for *Isleworth*, published in 1819 as an 'Elevated Pastoral'.

struck by this landscape embodiment of Claude's art and later drew several views of Stourhead.

The lure of the sea

Turner's models also included Dutch – notably Jacob Van Ruisdael and Aelbert Cuyp – and Italian landscape painters like Salvator Rosa, Zuccarelli and Canaletto.

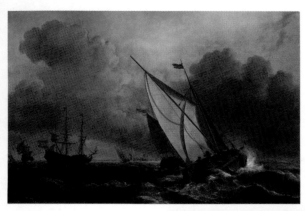

Where the Dutch artists were concerned, Turner appears to have followed the advice of Joshua Reynolds, made in 1781, that 'Painters should go to the Dutch School to learn the art of Painting, as they would to a Grammar School to learn Languages.' He was also very struck by the works of the great marine artists such as Willem Van de Velde the Elder (1611–93) and the Younger (1633–1707), whose intimate knowledge of the elements and subtle weather effects are matched by their equally precise rendering of ships and battles.

In a country that regarded its Navy with great reverence, sea painting constituted an art in its own

Below, *Fishermen at Sea*, 1796. Turner began painting large seascapes in the 1790s. The compositions are often highly dramatic, and the tensions created by the powerful contrasts can seem somewhat exaggerated. Like a distant sequel to works by Joseph Vernet or Philippe Jacques de Loutherbourg, these seascapes, with their foaming waves and gloomy storm clouds, orchestrate the elements of the sublime in amplified form.

'...all his works indicate a strong imagination. Nothing little appears from his hand and his work seems to take a comprehensive view of nature [but] shows an affectation of carelessness.'
The Porcupine,
28 April 1801

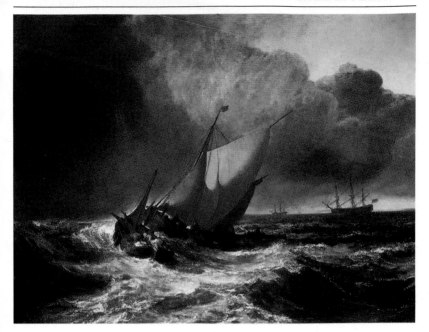

right. One of the marine artists enjoying a considerable measure of success in Britain at the end of the 18th century was John Thomas Serres (1759–1825), son of Dominic Serres (1722–93), a Frenchman captured by the English in 1752, who became marine painter to George III and was one of the founder members of the Royal Academy. John Thomas took over this royal office on the death of his father. He was forced to leave his marital home on account of his wife's indiscretions, and from 1799 to 1808 he lodged with Turner at 64 Harley Street, clearly providing Turner with an opportunity to benefit from his expertise. Author of the *Liber Nauticus*, the principal instruction manual for marine artists, Serres was well placed to offer his friend advice regarding his paintings of great naval battle scenes.

Long after these formative years, Turner kept up his 'dialogue' with the old masters, sketching their work and drawing constant nourishment from the example of others, whether Rembrandt, Titian or Watteau, or

Turner produced a number of pendants to famous works, either because he felt so inclined or because someone had challenged him to do so. The most famous of these challenges was in 1801 when the Duke of Bridgewater asked him to paint a pendant to *A Rising Gale* (opposite, above) a masterpiece by Van de Velde the Younger. Turner's response, *Dutch Boats in a Gale* (above), known as *The Bridgewater Sea-Piece*, was a genuine tour de force, a mirror version of Van de Velde's work.

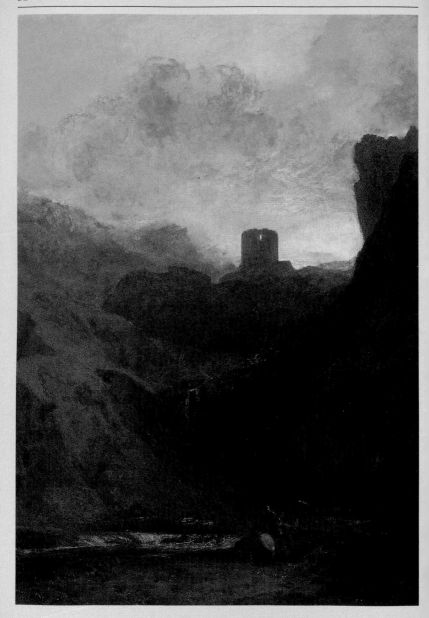

Many of Turner's pictures went through several preparatory stages and a variety of techniques. *Dolbadern Castle, North Wales* (opposite), the fruit of Turner's many visits to Wales in the 1790s, developed gradually out of a series of wash drawings (left, below), watercolours (left, above), pencil drawings and even a small oil. A whole collection of different views and experiments with colour testify to the complex evolution of this work, which Turner presented to the Academy on his election as an Academician.

When Turner showed *Dolbadern Castle* in 1800, it was the first time that he accompanied a work with lines of his own poetry: 'How awful is the silence of the waste, / Where nature lifts her mountains to the sky. / Majestic solitude, behold the tower / Where hapless Owen, long imprison'd, pin'd, / And wrung his hands for liberty, in vain.' Turner's reference to Owen Goch, a Welsh prince who was imprisoned in the castle from 1254 to 1277 by his brother Llewelyn, accentuated the tragic atmosphere of the painting.

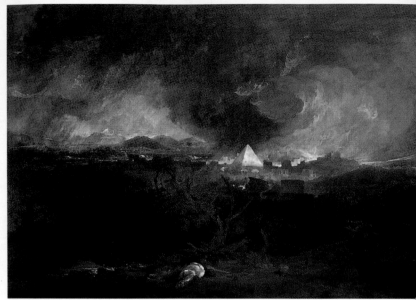

contemporaries such as Sir David Wilkie (1785–1841), the great genre painter of the early 19th century.

The idea of the sublime

The other tradition to which Turner was connected is more recent and relates to the notion of the sublime, a philosophical idea prior to its translation into artistic terms. The notion was developed by Edmund Burke in 1757 in *A Philosophical Enquiry into the Origin of our Ideas of the Sublime and Beautiful*. This text had a profound influence on the history of art and European romanticism in particular. The sublime in Burke's definition is based on man's feelings in the face of darkness and the elements unleashed in all their fury, in the face of the infinite and the infinitely uniform. As opposed to the balanced nature of beauty, the sublime awakens an interest in vast landscapes and terrible dramas. This was the era of the earliest horror novels – Horace Walpole's *Castle of Otranto* and, later, *Frankenstein* by Mary Shelley, whose monster, fleeing all human contact, takes refuge in the icy Alpine wastes.

Above, *The Fifth Plague of Egypt*, shown in 1800. In fact, the picture depicts the seventh plague, in which ashes and dust rained down on the land. The first of Turner's works to be based on the Old Testament, it clearly displayed the influence of Poussin and Richard Wilson (1713–82), the first English artist to dedicate his work exclusively to the portrayal of landscape. In 1800, its acquisition by one of the most influential men in England, the writer William Beckford, for the colossal sum of 150 guineas, greatly boosted Turner's reputation.

The notion of the sublime was central to Turner's work. It appeared both in his choice of subject matter – mountains, storms, volcanoes, fire – and in its treatment, and it evolved throughout his career, moving from the most literal interpretations to pure metaphor.

Academician at the age of twenty-six

On 4 November 1799, Turner was elected an associate member of the Royal Academy; his signature would henceforth be followed by the abbreviation ARA. This early election set him apart from his contemporaries, identifying him as the foremost artist of his generation. The following year, he showed his first historical painting, *The Fifth Plague of Egypt*. No longer a simple landscape painter, even less a topographical watercolourist, he began painting historical subjects and immediately established himself as the supreme exponent of the genre. In 1801, the huge public acclaim that greeted *Dutch Boats in a Gale*, commissioned by the Duke of Bridgewater, reinforced and boosted his fame. Barely a year later, on 12 February 1802, Turner was elected a full member of the Academy. As his Diploma picture, he offered the institution a painting that he had shown two year earlier: *Dolbadern Castle, North Wales*. At just twenty-six, he was the youngest Academician in the history of the institution, and from this point on, he signed his name 'J. M. W. Turner RA'.

Below, Turner as drawn by George Dance in March 1800, shortly after his election as an ARA, and later published in a series on 'eminent characters'.

JOS.ᵗ WILL.ᵗ MALLORD TURNER.

‘Often I have heard him in subdued tones try to persuade the excited to moderation. He would do this by going behind the speaker and by a touch or word soothe an acrimonious tone by his gentleness.’
George Jones, a friend of Turner

In addition to the honour of being elected to the Royal Academy, Turner began to enjoy the practical benefits of fame. His work was popular with the most avid collectors of the day and found its way into the finest collections. While continuing to exhibit at the Royal Academy and the British Institution, Turner soon had his works permanently on show at his own gallery.

CHAPTER 2

THE FREEDOM OF SUCCESS

Right, *Dort or Dordrecht* was shown at the Royal Academy in 1818 and the same year found its way into the drawing room at Farnley Hall, the home of Turner's patron and close friend Walter Fawkes. This watercolour, probably painted by Turner in situ to celebrate the hanging of the oil painting, also shows two other works by the artist. Opposite, a detail from a later Turner seascape, *Helvoetsluys – the City of Utrecht, 64, Going to Sea.*

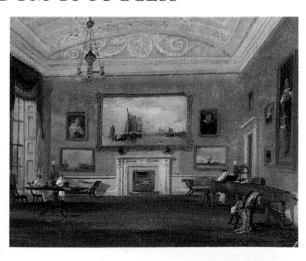

Rapid prosperity

With his election to the Royal Academy, Turner had secured himself the freedom to focus on new horizons and no longer needed to rely so heavily on the Academy's annual exhibition at Somerset House, which remained crucial to many artists of lesser reputation. There were a number of collectors who were absolutely passionate about his work and for some years had been busily acquiring his paintings, either at public exhibitions or by private agreement.

Thanks to these faithful collectors and to an inflationary rise in the price of his works, Turner was enjoying a rapid increase in his fortunes. Whereas, in 1796, his first oil painting, *Fishermen at Sea*, was bought by General Stewart for £10, in 1798 Turner sold two views of *Plompton Rocks* to Edward Lascelles, son of the Earl of Harewood, for £32. The prices rose exponentially, with the result that, in 1800, the writer and collector William Beckford (1760–1844), whom Turner had visited the previous year at his home, Fonthill Abbey, bought *The Fifth Plague of Egypt* for more than 150 guineas, and two years later the Duke of Bridgewater paid almost £300 for *Dutch Boats in a Gale*, known as *The Bridgewater Sea-Piece*. After this period of prodigious inflation, prices stabilized and, in 1835,

Turner's patron William Beckford (above) was the author of *Biographical Memoirs of Extraordinary Painters* (written at the age of twenty) and the gothic novel *Vathek*. Beckford's father was Lord Mayor of London and a well-known politician. He owned vast sugar-cane plantations in Jamaica and left his son one of the largest fortunes in England. William Beckford was also a discerning art collector. In 1799, he wrote to Turner from Portugal inviting him to his home, Fonthill Abbey in Wiltshire, to carry out a commission, and Turner spent the end of the summer of 1799 there.

Left, sketches by Turner from a letter to another of his patrons, Sir John Fleming Leicester.

Turner told a visiting member of his family that any one of the works in his studio could be had for £350. Some of his works went on to fetch much higher prices, however, even during the artist's own lifetime. *Palestrina* sold to a collector for £1,050, and in 1851 another paid £2,500 for two works that had in fact remained unsold for twenty-five years.

As part of his plans for the completion of Fonthill Abbey, in the 1790s, Beckford commissioned the architect James Wyatt to build a ruined gothic folly as a complement to the main building.

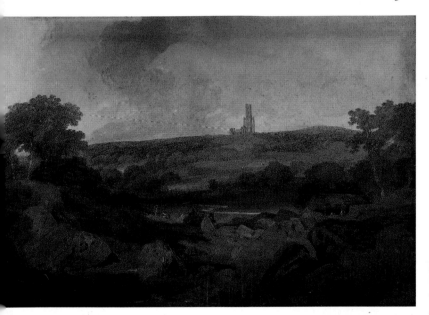

It is clear, therefore, that Turner enjoyed genuine prosperity from the outset of his career. In addition to the oil paintings, the watercolours, initially sold for a few pounds, ended up fetching considerable sums in the 1830s, when some views of England or the Alps were sold for between £50 and £100. Because Turner continued to lead a quiet life and dress simply, he sometimes acquired a reputation for meanness. Realistically, however, his all-consuming devotion to his art left him little occasion for spending money, added to which the modest circumstances of his childhood had scarcely prepared him for a life of extravagance.

What was originally intended to be no more than a shell grew into a huge castle, whose central tower collapsed on two separate occasions. Turner produced several watercolours of this extraordinary folly (above), showing it rising up out of the downs like some ghostly lost city.

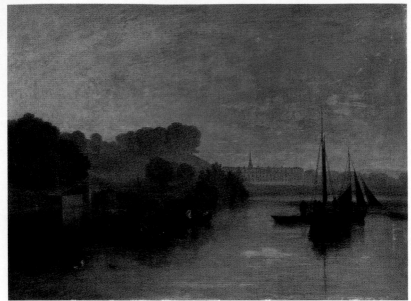

Lord Egremont, the perfect patron

In 1802, *Ships Bearing up for Anchorage* was bought by George O'Brien Wyndham, 3rd Earl of Egremont (1751–1837). From that day onwards, Wyndham was to be Turner's principal source of commissions, and enjoyed a close relationship with the artist. Following an emotionally turbulent youth (among other things, he was the natural father of the future prime minister, Viscount Melbourne), he withdrew from public life, retiring to his house at Petworth and devoting his time to agriculture and horses, as well as artistic patronage. This interest in the arts may well have been inspired by his mistress and future wife, Elizabeth Ilive, one of the few people, in 1800, to support William Blake, who painted *Satan Calling up his Legions* and *The Last Judgement* for her.

Lord Egremont was a generous and genial patron. He had little time for sycophants and socialites, but was eager that those he did invite into his home should enjoy the greatest possible freedom. His regular guests included

Above, *Petworth, Sussex: Dewy Morning*, 1810. Petworth is one of the most glorious stately homes in the south of England. Its gardens were designed by Capability Brown in 1750 at the behest of the 2nd Earl of Egremont, and the painting and sculpture gallery created by George Wyndham, 3rd Earl of Egremont, is one of the most beautiful in private ownership – 'quite the finest surviving expression of early nineteenth century taste', according to the historian Christopher Hussey.

the painters Thomas Phillips and
C. R. Leslie – and, of course, Turner
himself – and the sculptors Joseph
Nollekens, Richard Westmacott
and John Flaxman, whose last great
work, *St Michael Overcoming Satan*,
he commissioned in 1819.

His numerous visits to Petworth
gave Turner the opportunity to paint
and draw with an unusual degree of
freedom not only views of the gardens,
designed by Capability Brown, but also
interiors and scenes from daily life. His
sketchbooks, whether recording walks
through the grounds, or the rooms and
their inhabitants, or capturing the
atmosphere of the concerts, the music
and the quiet chatter, create a delightful
picture, preserving the memory of
Petworth life with all its freedom, its
festivity, its energy and its blend of
everyday detail and refinement.

Aristocratic admirers

Another member of the aristocracy who took a close
interest in Turner's art was the 3rd Duke of Bridgewater
(1736–1803), who owed his enormous fortune to
a canal network constructed in England's industrial
heartland and to the profits he had earned from his
mining interests during the Industrial Revolution.
He had begun his art collection in 1759 when he
commissioned a series of four paintings from Joseph
Vernet (1714–89), and had gone on to acquire works
by Raphael, Poussin and Titian, many of which had
previously formed part of the collection belonging
to the Dukes of Orleans. In 1801, he commissioned
Dutch Boats in a Gale (*The Bridgewater Sea-Piece*)
from Turner, intending it as a pendant to another work
in his collection, *A Rising Gale* by Willem Van de Velde
the Younger.

At around the same time, the Earl of Yarborough,
another of Turner's patrons, bought *The Festival upon the*

'His greatest pleasure
was sharing with the
highest and humblest
the luxuries of his vast
income. The very
animals at Petworth
seemed happier than in
any other spot on earth.'
Benjamin Robert
Haydon, speaking
of George Wyndham,
3rd Earl of Egremont
(portrait above)

Overleaf: Turner
produced many
pencil sketches and
watercolours of
Petworth – a colourful
chronicle of a place
whose inhabitants
all seem to be freely
pursuing their own
fancies, be it music,
painting or billiards.

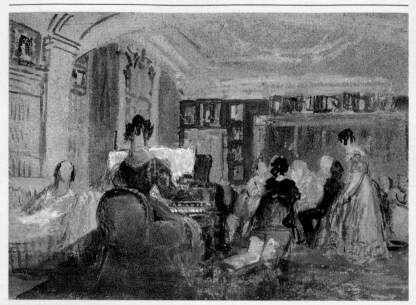

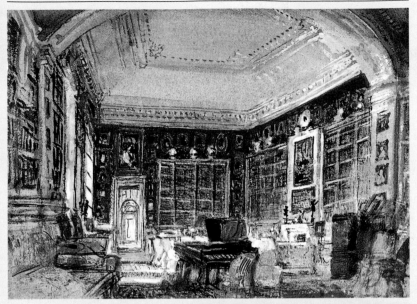

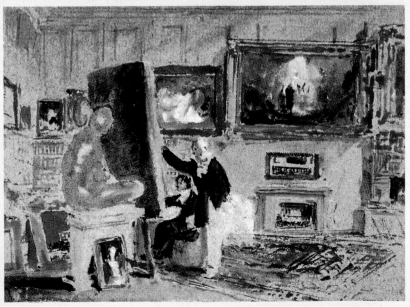

Opening of the Vintage at Macon, which Turner
had exhibited at the Royal Academy in 1803.
Lord Yarborough had previously asked
Turner to paint several watercolours
of the Brocklesby Mausoleum,
constructed by James Wyatt in memory
of the Earl's late wife. Lord Yarborough's
son later went on to commission the
painting *Wreck of a Transport Ship*.

At Farnley Hall,
Turner was free
to work as he chose.
Fawkes commissioned
him to produce a series
of studies of the estate,
and, working in close
collaboration with the
family, he also illustrated
a *Book of Ornithology*
(above, a heron) for
Fawkes's son Richard,
based on the system
of classification from
Thomas Bewick's
History of British Birds.

Fawkes: a patron and a friend

An amateur watercolourist in his own right, Walter
Ramsden Fawkes (1769–1825) was a patron worthy
of special mention. A radical politician on the left of
the Whig Party, Fawkes was a fervent supporter of
the abolition of slavery. At the end of the 1780s, after
completing his studies at Cambridge, he embarked on
his Grand Tour and returned from the Alps with some
excellent watercolours. He was also a landowner and art
collector and it was at his estate at Farnley, in Yorkshire,
that he regularly received Turner, whom he met at the
end of the 1790s. The artist was free to do as he pleased
and establish his own routines at Farnley, just as he had
been at Petworth, and Turner even appears to have

By the old oak
staircase (left),
located in the old part
of the house, Fawkes
displayed flags and
hunting trophies, as
well as a magnificent
painting by Frans
Snyders entitled
The Wild Boar Hunt,
acquired from the Duke
of Orleans in 1798. In
contrast with the older
parts of the house were
the more modern
rooms, where *Dort or
Dordrecht* and other
works by Turner hung.

provided Fawkes with plans for enlarging his house, drawing presumably on the architectural expertise acquired during his early training. His visits to Farnley were also an opportunity to join his host on hunting expeditions.

Turner's friendship with the Fawkes family continued after Walter's death in 1825. He became particularly close to one of Walter's sons, Francis Hawksworth Fawkes, lending him paintings when his friend could not afford to buy them. *The Victory Returning from Trafalgar*, a painting of Nelson's flagship, *London from Greenwich Park* and the magnificent *Dort or Dordrecht* were all pictures that graced the Fawkes family home at one time or another. As well as oil paintings, Fawkes also commissioned watercolours on Alpine themes, views of the Rhine and views of his own house from Turner. The Fawkes family also embarked on the unusual project of publishing five volumes devoted to birds, their plumage

As well as painting, Turner and Fawkes shared a love of the hills, and a passion for history and politics. They also enjoyed the more visceral pleasures of hunting, as seen below in a painting by J. R. Wildman. Fawkes was among the first to acquire one of Turner's sketchbooks (of the Rhine) and held a public exhibition at Farnley in 1819 to bring Turner's drawings to the attention of the critics. One critic wrote: 'this artist's fame can acquire no better vindication than this collection.'

Painted in 1827 for William Moffatt, who owned a house overlooking the Thames at Mortlake, *Mortlake Terrace* (left) once again shows the influence of Claude. The oblique perspective, the rhythmical sequence of light and shade created by the line of trees, and the dog, standing on the low wall silhouetted against the light, are among the unusual features that mark a break with classical tradition. The black shape of the dog was a late addition, apparently a paper cut-out which Turner stuck on to the canvas and painted in, shortly before the Academy's varnishing day in 1827. The painting was criticized by the press for its strident yellow key.

Overleaf: *Dort or Dordrecht*, which Turner showed in 1818, has always been regarded as one of his most cheerful works. The tranquil sea, the peasants arriving with food for the passengers and the beauty of the town in the background create an effect of complete harmony – a scene of contentment contrasting with the impressions associated for Turner, a short time earlier, with his visit to the sites of the Napoleonic Wars.

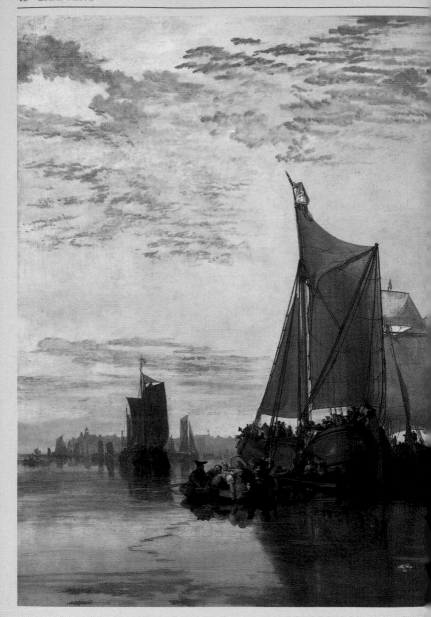

and their eggs, collections for which Turner produced watercolour illustrations.

A new audience

At the beginning of the 19th century, British art collectors fell into two categories: the traditional members of the aristocracy and gentry, and members of a rapidly expanding middle class that included wealthy shopkeepers and industrialists based in major towns and cities. Turner found a great many supporters – some of them rather unusual – among the latter.

One of these was Elhanan Bicknell (1788–1861), who made his fortune from the whaling industry. Bicknell began collecting works by Turner in 1838, relatively late therefore, but rapidly built up a collection that included *The Bright-Stone of Honour (Ehrenbreitstein)*, together with seven or eight other oil paintings, and eighteen watercolours, including *The Blue Rigi*. His relationship with Turner had its stormy moments. When in 1845, for example, Bicknell declined to purchase four paintings on the theme of whaling, a subject that he had suggested to Turner, the artist broke all contact with him. In fact, Turner's interest in whaling, which was regarded at the time as heroic, predated this episode, since a watercolour of a beached whale (probably inspired by a novel by Sir Walter Scott entitled *The Pirate*) dates from 1837.

Another great collector of Turner's works was Joseph Gillott (1799–1872), who made his fortune manufacturing steel pens. Gillott rapidly assembled one of the most impressive Turner collections, including some twenty oil paintings and an even greater number of watercolours.

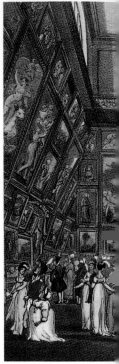

Below, a press announcement of the Royal Academy's annual exhibition.

'On the line'

Since his election to the Academy at the age of twenty-six, Turner had enjoyed a string of

ROYAL ACADEMY, SOMERSET PLACE.
THE EXHIBITION is NOW OPEN, and will continue EVERY DAY (Sundays excepted) from Eight in the Morning till Seven in the Evening.
JOHN RICHARDS, R. A. Secretary.
Admittance One Shilling—Catalogues Sixpence.
☞ The Students who are not Exhibitors are to apply for their Tickets on Monday the 7th instant.

EUROPEAN MUSEUM. 1804
THE celebrated BLACKSMITH of ANT-WERP is arrived, and will be placed this day in the above National Gallery. The Nobility and Gentry who patronise and admire the fine Arts, have now an opportunity of viewing this splendid Collection, and enriching their Cabinets upon terms uncommonly moderate. The Sale by Private Contract, at the reduced prices, will be continued daily during the week, from 12 o'clock till 4 in the afternoon. J. WILSON, Manager.
Admittance 1s.

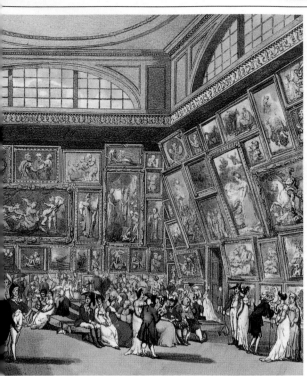

Left, a view of the Great Room at Somerset House during the Royal Academy exhibition of 1807. By the 1820s, the Academy exhibition attracted almost ninety thousand visitors over five weeks. As the exhibition grew ever more popular and the number of exhibitors continued to increase, it became necessary to convert other rooms into exhibition areas. There were endless arguments over the positioning of paintings, and the changes demanded by the artists could lead to a whole wall having to be rehung.

•Your pictures are hung at the Academy, but not to my satisfaction at least.... If you still think, notwithstanding their situations are as unfortunate as could possibly be allotted to them...that their remaining there may be advantageous to you – *there they shall remain*, but if indifferent about their being exhibited there, with me or at the *British Institution next season*, I must confess I should like to have the option of withdrawing them....•
Turner in a letter to his friend James Wyatt, 13 April 1812

successes. He had served as a member of the Academy's Council for a number of years and been co-opted on to the critically important Exhibition Committee, whose job was to decide where individual works should hang in the Great Room at Somerset House. This was a subject of constant controversy between artists, since everyone wanted to see their work hung 'on the line' – in the position that showed it off best, with its bottom edge on the line separating the vertical wall and the sloping overhang. The worst position, particularly for medium-sized canvases, was the top of the sloping wall (potentially as high as eight rows up). Turner himself had been known to complain bitterly about the positioning of his works, having argued with John Constable on the matter in 1831, when Constable was a member of the Committee but Turner was not.

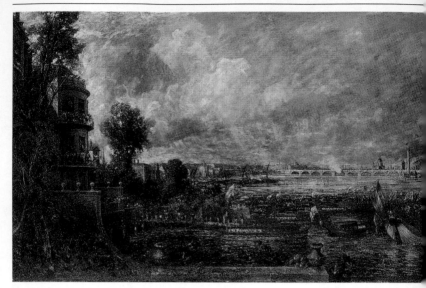

Turner could be extremely competitive and was quite capable of altering his own pictures to the detriment of their neighbours, as was demonstrated by an incident that occurred in 1832. Constable was showing *The Opening of Waterloo Bridge*, a painting bursting with magnificent reds, and a virtually monochrome picture by Turner, *Helvoetsluys – the City of Utrecht, 64, Going to Sea*, had been hung alongside it. 'In 1832,' Constable's biographer, C. R. Leslie, tells us, 'when Constable exhibited his *Opening of Waterloo Bridge*, it was placed in the school of painting – one of the small rooms at Somerset House. A sea-piece, by Turner, was next to it – a grey picture, beautiful and true, but with no positive colour in any part of it. Constable's *Waterloo* seemed as if painted with liquid gold and silver, and Turner came several times into the room while he was heightening with vermilion and lake the decorations and flags of city barges. Turner stood behind him, looking from Waterloo to his own picture, and at last brought his palette from the great room where he was touching another picture, and putting a round daub of red lead, somewhat bigger than a shilling,

Every year for some ten years, John Constable announced his intention of showing *The Opening of Waterloo Bridge* (above) at the Academy, only to keep changing his mind at the last moment. He was still working on the painting in February 1832, when the Prince Regent's boats sailing from Whitehall for the opening ceremony were a distant memory. In May 1832, visitors to the Academy were finally able to admire Constable's masterly work, its surface churned by knife marks and glittering with flickers white light – a contrast to the elegant refinement of Turner's work.

on his grey sea, went away without saying a word. The intensity of the red lead, made more vivid by the coolness of his picture, caused even the vermilion and lake of Constable to look weak. I came into the room just as Turner left it. "He has been here," said Constable, "and fired a gun." ...The great man did not come again into the room for a day and a half; and then, in the last moments that were allowed for painting, he glazed the scarlet seal he had put on his picture, and shaped it into a buoy.'

It was not the first time that Turner had become involved in this kind of gamesmanship. Some ten years earlier, he had behaved in a similar fashion when a work of his had appeared alongside one by Martin Archer Shee. It was an act of provocation, and Shee did not forget it: when he became President of the Royal Academy, he decided that varnishing days should be drastically reduced.

A symphony of greys, *Helvoetsluys – the City of Utrecht, 64, Going to Sea* (below) has, like several other works by Turner, been sometimes regarded basically as a cloudscape, a monochrome study experimenting with subtle gradations of tone and lacking the structure imposed by real objects or a true sense of perspective. The influence of Dutch art is evident in this type of seascape, as well as in the titles (which sometimes included invented names – *Port Ruysdael*, for example).

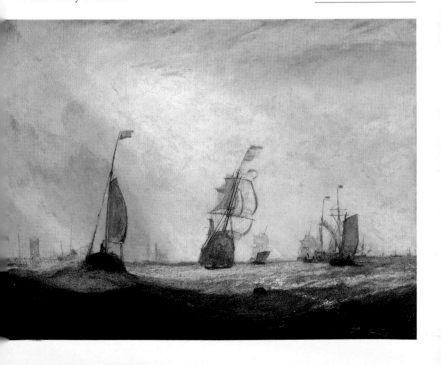

Other honours

On 2 November 1807, Turner was elected Professor of Perspective at the Royal Academy, and between 1811 and 1828 he gave more than sixty lectures on the subject. The notion of perspective may seem irrelevant in an artist whose every landscape appears to be on the point of breaking up, but it was in fact an integral part of Turner's training and of much of his work. The father of his teacher, Thomas Malton, had written the most important treatise on perspective of the 18th century. We should not overstate Turner's importance in this area, however: the text of his lectures demonstrates an approach that was neither particularly innovative nor always very clear, and Turner had already stopped teaching by the time that he officially resigned from the post.

Much later, in 1845, he took the President's chair at Royal Academy meetings while the President, Sir Martin Archer Shee, was ill, and later accepted the post of Deputy President after Shee resigned. This final distinction confirmed the important position that Turner occupied, throughout his career, at the centre of English artistic life.

●One kind of reflection had a special significance for Turner ...reflections in various metals with different degrees of polish. He was evidently interested in the precise conditions in which reflected light became an image – in mirrors, in window panes and on the surfaces, exterior and interior, of spheres.●

Lawrence Gowing, in *Turner: Imagination and Reality*, 1966

At the British Institution

Turner remained loyal to the Royal Academy, but soon found that he had little time for its internal wranglings. Arguments were continually breaking out between the supporters of royal patronage and the champions of independence, and, in 1806, Turner began showing works at the British Institution as a way of escaping the bad atmosphere. The British Institution had been founded the previous year by a group of enthusiasts eager to create a rival to the Academy that was free from the stranglehold of a small handful of artists. The originators of the scheme included Sir George Beaumont and an eminent member of Lloyds underwriters, John Julius Angerstein, both of them enthusiastic collectors whose assembled works eventually formed the nucleus of London's National Gallery a few years later.

The rooms of the British Institution, in Pall Mall, had previously been occupied by the Shakespeare Gallery, created in the 1780s by John Boydell, famous as a publisher of engravings and later Lord Mayor of London. Turner continued to exhibit there – either new works or works shown at the Academy in previous years – until 1846. It was also at the British Institution that Turner encountered the fiercest debates over his art, in particular the criticisms of Sir George Beaumont. While continuing to show his work regularly at the Academy

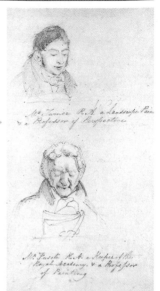

Mr. Turner R.A. a Landscape Painter & a Professor of Perspective

Mr. Fuseli R.A. a Keeper of the Royal Academy, & a Professor of Painting

•Half of each lecture was addressed to the attendant behind him, who was constantly busied, under his muttered directions, in selecting from a huge portfolio drawings and diagrams to illustrate his teaching [opposite, above].... As illustrations of aerial perspective and the perspective of colour, many of his rarest drawings were at these lectures placed before the students in all the glory of their first unfolded freshness.**•**
Richard Redgrave, 1866

Above, sketches of Turner and Henry Fuseli, by Thomas Cooley. Left, Turner's studies of metal spheres.

and the British Institution, Turner also felt motivated to create a gallery of his own to meet the growing demands of his public.

Turner's Gallery

Only two years after becoming an Academician – and before reaching the age of thirty – Turner decided to open a gallery where he could show his own works to the public. It was a bold initiative, but one that needs to be put into context: Sir Joshua Reynolds, Thomas Gainsborough and Benjamin West (to mention only three great painters) had all done the same, although admittedly at a more mature age. It was also common practice among many British artists to dedicate a section of their studio to the display of their work, be it paintings or sculptures.

Turner's decision, however, was prompted by a rather different ambition, since he envisaged his gallery continuing after his death, serving as a museum and as a place where young artists in difficulty could find both a refuge and a place in which to work. Built in 1804 on the site adjacent to his own house in Harley Street, Turner's first gallery measured 70 feet by 20 feet (20 metres by 7 metres). While continuing to show his best works at the Academy's annual exhibition and, to a lesser extent, at the British Institution, Turner used his own gallery as a permanent showcase for around twenty paintings, together with a number of watercolours and drawings, notably those destined for his *Liber Studiorum*.

In 1811, the gallery closed for building works, and then again in 1818, to allow for a new extension. The new rooms, opened in 1822, looked onto both Harley Street and Queen Anne Street. Having his works on permanent display did a great deal for Turner's reputation, even if he tended to show paintings that had already been viewed at the annual exhibitions or had failed to find a buyer. Open all year round, the gallery gave

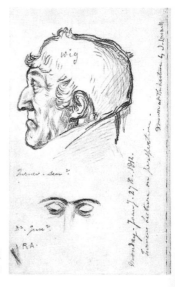

Turner's gallery as painted by George Jones (left) is a rare surviving image of what it was like. The walls were covered with paintings, watercolours and drawings – illuminated by skylights – and there were often others propped on the floor. Below, a handwritten invitation by Turner to an exhibition at his gallery in May–June 1814.

Opposite, Turner's father, drawn by John Linnell. He acted as his son's secretary and agent, working with great dedication. After his father's death in September 1829, Turner started to pay less

not just the cognoscenti, but also curious passers-by, the opportunity to appreciate the great artist's talent.

The Sister Arts

It became commonplace for Turner's exhibited works – whether at the Academy or the British Institution, or in his own gallery – to be accompanied by a literary quotation. This interest in literature drew on an earlier English tradition of interweaving painting and poetry, the 'Sister Arts' as they came to be known – an association that itself dated back to antiquity, and which artists like Reynolds developed as a means of lifting painting out of the realm of the purely manual. English painters, moreover, were also assiduous writers, publishing treatises or historical works, and also poems, in opposition to the anti-intellectual tradition. The poet, painter and engraver William Blake was perhaps the

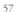

attention both to his personal appearance and to his gallery. Visitors in the 1840s remarked on the sorry state of the place: the glass panels in the the ceiling leaked and, despite the beauty of the art, an air of neglect hung over the place.

supreme example of this integration of the arts, and among Turner's other contemporaries, Richard Westall and Martin Shee also published poetry, while Reynolds often emphasized the importance of reading as a way of exercising an artist's creative imagination.

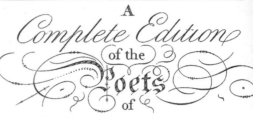

A
Complete Edition
of the
Poets
of
GREAT BRITAIN.
Volume the Ninth.
——— *Containing* ———
Swift, Thompfon, Watts, Hamilton, A Philips, G. Weft,
Collins, Dyer, Shenftone, Mallet, Akenfide & Harte.

Turner followed the same principles, and went even further. The margins of his sketchbooks are littered with lines of poetry and random jottings on the most varied themes, as well as verses copied in the course of his reading. And Turner's predilection for poetry became even more apparent after 1798, when the Academy authorized, indeed encouraged, the inclusion of quotations of poetry alongside the title of works in the annual catalogue.

Above, the fourteen volumes of Robert Anderson's anthology *Poets of Great Britain* (1793–95) introduced Turner to poets such as Chaucer and Chatterton.

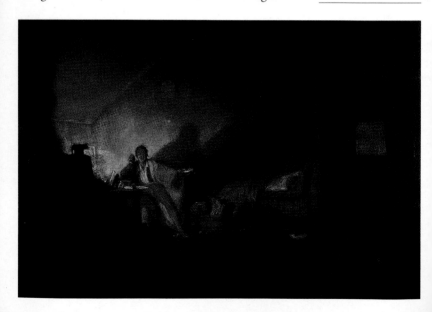

171	Portrait of Mr. Serjeant Best	—	*S. Woodforde*, R. A.
172	View of Plymouth Dock and Hamoaze, taken from Mount Edgecumbe	—	— *W. Daniell*, A.
173	A straw yard	—	— *J. Ward*, A.
174	Portrait of Miss Forster	—	*H. Singleton*
175	The garreteer's petition		*J. M. W. Turner*, R. A.

" Aid me, ye Powers ! O bid my thoughts to roll
In quick succession, animate my soul ;
Descend my Muse, and every thought refine,
And finish well my long, my *long-sought* line."

Scattered throughout the exhibition catalogues are the names of his poetic and literary passions, both early – Virgil, Pope, Milton, Thomson and Gray – and modern – Byron and Scott.

On the relationship between painting and poetry, Turner paraphrased the writer Mark Akenside in one of his lectures and wrote in 1812: 'Painting and poetry, flowing from the same fount mutually by vision, constantly comparing Poetic allusions by natural forms in one and applying forms found in nature to the other, meandering into streams by application, which reciprocally improve, reflect, and heighten each other's beauties like...mirrors.'

It was from that year onwards that quotations from a poem written by Turner himself began to appear beneath the titles of his pictures. Its title, *The Fallacies of Hope*, was probably inspired by a poem by James Thomson, entitled 'Autumn', in which the poet refers to 'fallacious hope'. It is difficult to imagine the exact nature of Turner's poem, since no manuscript or rough draft has survived, and the poem was probably never finished or even properly shaped, but the themes that emerge through the quotations relate to reflections on history, the illusion of human ambitions, and visions of an apocalyptic nature.

Opposite below, *The Garreteer's Petition*, 1809. The scene depicts a young poet in his garret, the chiaroscuro effects reinforcing the contrast between his ambition and the pitiful reality of his room. Above, an excerpt from the Academy's 1809 exhibition catalogue including Turner's caption to this picture (the words spoken by the poet himself): 'And me, ye Powers! O bid my thoughts to roll / In quick succession, animate my soul; / Descend my Muse, and every thought refine, / And finish well my long, my *long-sought* line.' Turner was passionate about poetry, as is clear from his penchant for quotations, whether taken from established writers or lines of his own, like these.

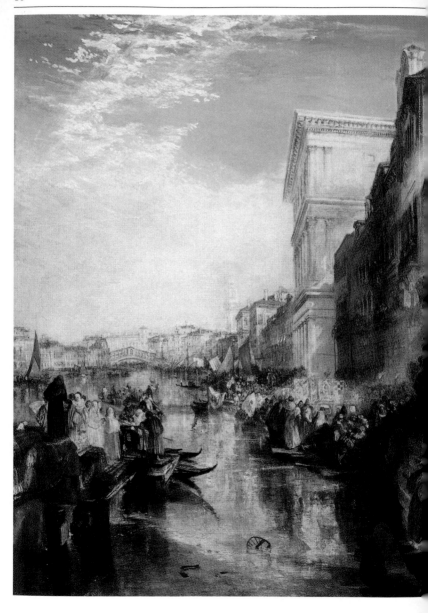

From 1817 until his death in 1851, Turner travelled extensively, both in Britain and also across Europe, from Italy to Denmark and from Austria to the coasts of France. Perhaps no other artist has studied the world with such infinite attention, equally fascinated by the natural spectacle of the Alps and by the weight of history that he felt all around him in Venice or Rome. As well as finding new subjects, Turner used these journeys as a way of reflecting on art and on the whole process of seeing.

CHAPTER 3

ARTIST AND TRAVELLER

Turner always made a point of studying the places he was planning to visit before departure, using maps and guidebooks like this *Manuel du voyageur* (right) by Madame de Genlis (former tutor to the future King Louis-Philippe), marked with Turner's handwritten annotations. Opposite: *The Grand Canal, Venice*, 1837.

MANUEL DU VOYAGEUR,

OR,

The Traveller's Pocket Companion;

CONSISTING OF

FAMILIAR CONVERSATIONS

IN ENGLISH AND GERMAN,

WITH MODELS OF LETTERS, NOTES, &c.

ALSO

A TABLE OF GERMAN COINS, AND THEIR RELATIVE VALUE
IN ENGLISH MONEY.

BY MADAME DE GENLIS.

NEW EDITION, ENLARGED AND GREATLY IMPROVED.

LONDON: PRINTED FOR SAMUEL LEIGH, 18, STRAND,
AND BALDWIN AND CRADOCK, PATERNOSTER-ROW.

Five Shillings Half-bound.

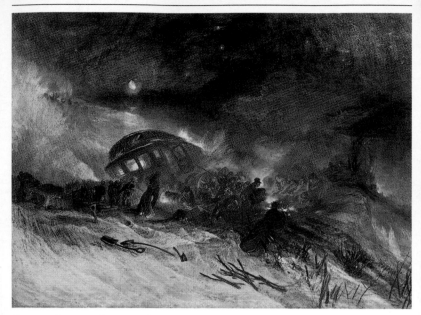

'A grandeur and a grace'

In 1833, an anonymous French critic, writing in
L'Artiste, marvelled at the work of Turner: 'There is
something dream-like and intangible in Turner's genius
which is singularly at odds with reality. Give Turner
Wales, England, the Loire, the Pyrenees, the Alps, give
him the Colosseum or the Doge's Palace, and he will
imbue them all with a grandeur and a grace; he will
establish a mysterious relationship between the most
widely differing climates.' The same critic continued:
'You can protest all you like: he refuses to acknowledge
the existence of those impenetrable mists that wrap
themselves around Edinburgh's old city. Nor can you
expect him to be satisfied with that glaring light which
throws the Naples skyline into such sharp relief. No,
he takes nature as he finds it, just as the ingenious
marquises of the Ancien Régime took Carmontelle's
proverbs, and he embroiders and embellishes it,
manipulating it to suit his needs. He expands it
and mutilates it as the fancy takes him. There can

A bove, *Snow Drift upon Mount Tarrar*, a watercolour of 1829.

'We were capsized on
the top. Very lucky it
was so; and the carriage
door so completely
frozen that we were
obliged to get out at the
window.... We had to
march or rather flounder
up to our knees nothing
less in snow all the way
down to Lancesbyburgh
[Lanslebourg] by the
King of Roadmakers'
Road... filled up
with snow and
only known by the
precipitous zig-zag....'
Turner in a letter to
James Holworthy,
January 1826

be no cause for complaint, however: for the results are miraculous.'

From the Alps to the Loire, from Venice to the banks of the Rhine, from Scotland to the Seine, from Wales to Rome, in the course of the many journeys dotted throughout his life, Turner found the true subject of his works, with light and water curiously favouring the development of an incandescent style of painting, just as the mountain peaks and the gathering mists became for him sources and repositories for the sun's rays.

A methodical but absent-minded traveller

Turner tended to visit friends and patrons during the winter, reserving the summer months for his major expeditions. The end of the Academy summer exhibition was generally the moment when he chose to leave. Turner was pragmatic in his approach, carefully preparing his journeys down to the last detail, reading guides and travel accounts, and either studying or copying the maps that came to hand. To compensate for his lack of French and Italian, he took care to note a number of useful words and expressions in his sketchbooks; and sometimes one of his friends would provide an itinerary for him, pointing out which places to avoid and which not to miss. The equipment he took with him consisted of drawing books of various sizes, which, being lightly bound, had the advantage that he could roll them up in his pockets. As protection against potential dangers on the road, he armed himself with an umbrella that had a long blade concealed in its handle.

Despite these precautions, it appears that Turner was extremely absent-minded. A childhood friend, Clara Wells, recounted that he only ever returned with half of what he had set out with and frequently lost his sketchbooks. And that was without counting all the many minor incidents and

Intent on travelling light at all times, Turner devised a rather unusual watercolour set (below), using the binding from an old almanac with some of the pages removed and small cakes of paint glued inside. The result was a simple and practical piece of equipment that could be taken anywhere, although in fact Turner generally restricted himself to pencil sketches when he was working outside, reserving the evenings back at his lodgings for painting in watercolour.

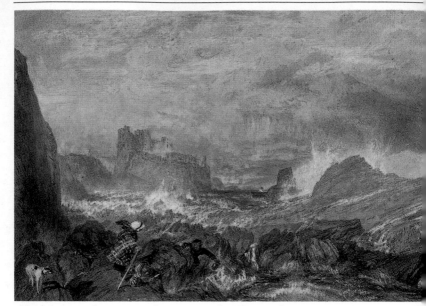

misadventures that occurred en route, often due to the state of the roads (and which inspired some unusual works). Hearing Turner describe yet another of his falls, his friends the Fawkes family henceforth nicknamed him 'Overturner'. During the course of his travels, Turner worked constantly. He would occasionally listen to his fellow travellers conversing while they journeyed together by stage coach, or might make notes on local costumes, but he was not especially interested in the people he encountered, or their habits and lifestyles, any more than he was interested in the political events of the countries through which he travelled, often only learning about them on his return to England.

While working out of doors, Turner was generally content to make sketches and suggest colours with brown or grey washes. Occasionally, where the circumstances allowed him to work in greater comfort, he indicated the essential tones in watercolour; but he had an extraordinary memory for places and colours and more often than not merely noted a few salient details, holding in his mind, sometimes for months, an overall

E ven a simple frontispiece vignette, like the image of Edinburgh Castle below, frequently involved considerable work, including several preliminary sketches.

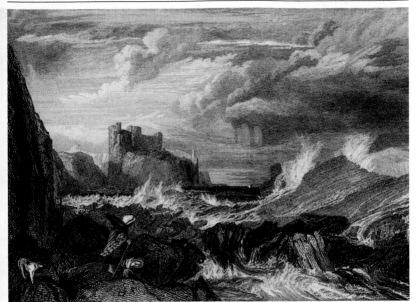

picture of a scene, complete with colours and atmospheric effects. His sketchbooks were his raw material, which he used later to produce large watercolours – which were carefully finished off, even if they often convey that sense of the indefinable so characteristic of Turner's work – and oil paintings, as well as hundreds of engravings.

Tours and detours in Great Britain

For many years, however, the Napoleonic Wars made it impossible for him to visit Europe, so Turner had to content himself with exploring England, Scotland and Wales. Wales provided him with an extensive source of material – 'the distant clouds floating in a line waving – & tinged with the most beautiful pearly tints – the whiter parts clear beyond expression', he wrote of Lake Bala in his journal in 1792 – but the painter was even more taken with Scotland. In 1818, a publisher of engravings asked him to illustrate Walter Scott's *The Provincial Antiquities of Scotland*, and he visited some of the most famous Scottish castles, including Tantallon,

Opposite, Turner's watercolour original of *Tantallon Castle*, and above, the engraving. Several of the artist's watercolours were commissioned by print publishers. He generally took great care over the production of these prints, which were often executed in aquatint, sometimes on steel if a large number of prints were required. Turner demanded high-quality printing techniques and charged high fees for his work, and he retained the proofs so that he could give them to friends. Publishers often found their profits substantially reduced; a few even went bankrupt.

Craigmillar, Crichton and Roslin. In 1831, he returned to Scotland, this time to collect material for the *Poetical Works and Prose Works of Walter Scott*, whom he met at the writer's home in Abbotsford. Principally thanks to Scott, Scotland had become a subject of interest for the whole of Europe, and by producing an illustrated edition Turner hoped to satisfy the insatiable demand for views of Scottish landscapes from keen readers of *The Bride of Lammermoor* and *Rokeby*.

Engravings by the hundred

Meanwhile, Turner continued to travel all over his native England. Ever since William Gilpin had begun the craze of the Picturesque Tour in the second half of the 18th century, England had been Turner's favourite part of the world, and one that he never tired of revisiting. The project that demonstrates this love most clearly is the series entitled *Picturesque Views in England and Wales*. This work showed the painter at the height of his powers, producing watercolours that are wonderfully subtle in their treatment of detail. Not only did Turner succeed in creating a fresh vision of landscapes whose fame, in some cases, had led to over-familiarity; he also displayed a huge variety of approaches to the country as a whole, recording not only landscapes, but also human activities, from the most traditional to the most modern, as well as evidence of economic and social changes.

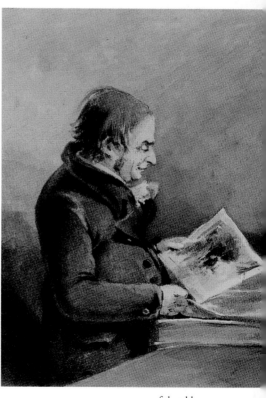

Prints occupied an important place in Turner's working life. This watercolour by John Thomas Smith (below) shows him engaged in study in the British Museum's Print Room. In addition to his interest in the work of the old masters, Turner worked closely with his own engravers, and letters to engravers and publishers make up a large part of his correspondence.

Commissioned by the print publisher Charles Heath in 1824, this project rolled on until the mid-1830s. It involved Turner in the production of a hundred medium-sized watercolours, which were intended to be reproduced as mezzotints. A number of factors, including the substantial sum offered to Turner, the many technical demands which he made on the engravers, and the delays in sales, rapidly conspired, however, to make this a perilous enterprise. Despite the regular exhibition of the paintings and the beauty of the resulting plates, success could not be guaranteed in a market that in any case was saturated with other prints of Turner's work. Heath was ruined by the affair, which had cost him almost £17,000 and brought very small returns.

This ambitious but unfortunate enterprise was not atypical of Turner's publishing ventures. His publishers never tired of offering the public (both in Britain and in Europe) Turner prints, which they produced by the hundred, simultaneously satisfying not just an interest in the artist, but also a curiosity to know more about the world. Turner's celebrity owed much to the diffusion of these prints.

Ruskin follows Turner's trail

The discovery of one of these vignettes, in a book given to him by his parents when he was only thirteen, had a determining effect on the life of John Ruskin (1819–1900) and marked the beginning of a passion for Turner that was to carry him from the Scottish moors to the far south of Europe, and from Denmark to the Alps. Ruskin even dragged his parents to Europe, persuading them to accompany him on a pilgrimage to the sites painted by the artist. On 22 June 1840, he met his hero

Left, a portrait of John Ruskin by Francis Holl. The young Ruskin's enthusiasm for Turner's work led him to give his book *Modern Painters* the subtitle *Their Superiority in the Art of Landscape Painting to the Ancient Master*s (title page, below). Ruskin's writings became influential throughout Europe. The notion that artists are free to reject the teachings of the old masters underpins all of his work and marks a radical break with artistic tradition. Ruskin's opposition to the devastating effects of industrialization was rooted in his radicalism and almost messianic faith. Ruskin was also an active supporter of the Pre-Raphaelites, but he was savagely critical of Whistler.

for the first time at a mutual friend's house. 'Introduced to-day to the man who beyond all doubt is the greatest of the age,' Ruskin wrote in his journal – 'greatest in every faculty of the imagination, in every branch of scenic knowledge; at once the painter and poet of the day...I found in him a somewhat eccentric, keen-mannered, matter-of-fact, English-minded gentleman: good-natured evidently, bad-tempered evidently, hating humbug of all sorts, shrewd, perhaps a little selfish, highly intellectual, the powers of his mind not brought out with any delight in their manifestation, or intention of display, but flashing out occasionally in a word or a look.'

Ruskin was highly talented in his own right, writing, teaching and painting with bewildering ease. In 1843, at the age of twenty-four, he published the first of a five-volume work entitled *Modern Painters*, in which he described Turner as the master of the field of landscape painting.

An affinity with the Alps

On his first visit to Europe, in 1802, Turner headed straight for the Alps – in preference, even, to visiting the Louvre. His choice of destination may perhaps have been influenced by his travelling companion, a young English gentleman by the name of Newby Lowson, but the Alps and Switzerland

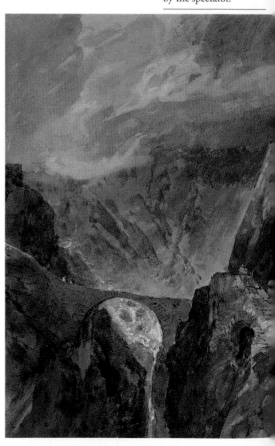

This watercolour of the Devil's Bridge in the Swiss Alps – a scene Turner painted in several versions – demonstrates the principle of the sublime, 'whatever is terrible with regard to sight', in the words of Burke. The apparent fragility of the bridge intensifies the feelings of vertigo experienced by the spectator.

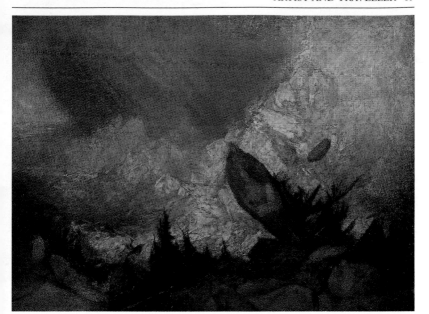

exerted an immediate fascination on Turner, who returned there on several occasions. Between 1802 and 1844, he crossed the mountain range some eight or nine times in his journeys from Savoy to the Tyrol, and from northern Italy to Germany. The Alps became a recurrent motif in his work, coming to form its geographic and artistic heart.

The mountains had exercised a fascination on painters before him – in particular English artists such as John Robert Cozens, Francis Towne and John Warwick Smith – but none had actually explored them with such curiosity and dogged determination. There was certainly a novelty about the Alps, which was part of their attraction at the time. The 18th century was passionate about this icy

Above, *The Fall of an Avalanche in the Grisons* was inspired by *An Avalanche in the Alps* by de Loutherbourg (below): 'Down at once, its pine-clad forests, / And towering glaciers fall, the work of ages / Crashing through all!'

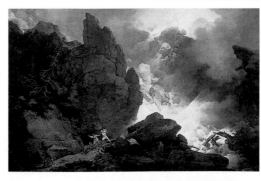

wasteland, which previous generations had feared and shunned. In 1786, Jacques Balmat and Dr Michel Gabriel Paccard were the first to reach the summit of Mont Blanc, and their efforts marked the beginning of serious mountain exploration. And a few years later, the Alps provided the location for some of the dramatic episodes in Mary Shelley's novel *Frankenstein*.

With Turner, the mountain landscape lent itself to every possible pictorial variation. In contrast to the Romantic notion of the sublime that imbued the earliest depictions of mountain scenery, Turner began by developing a classical vision more closely influenced by Poussin than by the atmosphere of awe and dread characteristic of his contemporaries. His early Alpine landscapes were based on an awareness of geometry and perspective that was direct evidence of his classical training. Then, with his greater assurance in terms of technique and a growing familiarity with his subject matter, his approach soon changed, and he allowed himself to be transported by a sense of the sublime. His interest in history gave an additional dimension to images such as *Snow Storm: Hannibal and his Army Crossing the Alps*, a picture that prompted an enthusiastic

A bove and opposite (detail), *Snow Storm: Hannibal and his Army Crossing the Alps*, 1812. It was probably Jacques Louis David's *Bonaparte at Mont St.-Bernard*, which Turner saw in David's studio in 1802, that awakened his interest in this theme. Turner depicts the Carthaginian troops in disarray, trapped in an icy apocalyptic waste.

'...the fierce archer of the downward year / Stains Italy's blanch'd barrier with storms. / In vain each pass, ensanguin'd deep with dead, / Or rocky fragments, wide destruction roll'd.'
Turner's caption for *Hannibal and his Army Crossing the Alps*

response from the critics. 'This is a performance that classes Mr Turner in the highest rank of landscape painters, for it possesses a considerable proportion of that main excellence of the sister Arts, Invention,' wrote the critic for *The Examiner* in June 1812. 'A terrible magnificence is also seen in the widely circular sweep of the snow whirling high in the air.... In fine, the moral and physical elements are here in powerful unison blended by a most masterful hand, awakening emotions of awe and grandeur.'

This fruitful fascination with lofty peaks and yawning chasms was finally succeeded by the grand and harmonious evocations of Turner's final decades – sunsets playing on the opposition of warm and cold tones, as in his views of Goldau in 1843.

The dream of Italy

Turner's work is saturated with impressions of Italy, its landscapes, its artistic creations and its history. From the

Overleaf: *The Red Rigi*, 1842, probably painted from the shore of Lake Zug. Turner travelled to Switzerland every year from 1841 to 1844 and produced several studies of this view, as well as watercolours, or 'samples' as they were known. These gave potential purchasers a number of different options relating to the angle of the view and the colours used. Once the collector had made his choice, Turner then executed the work in large format, finishing it off to his client's requirements.

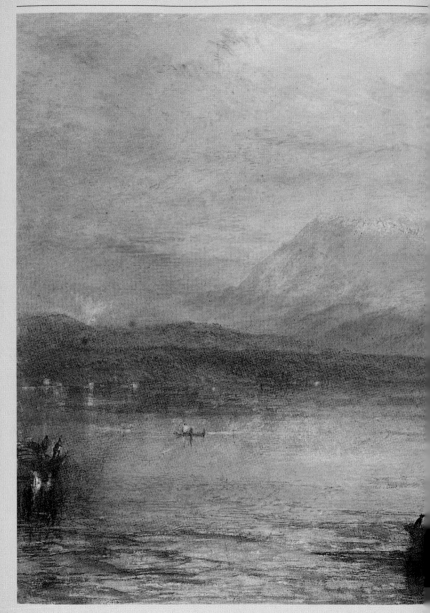

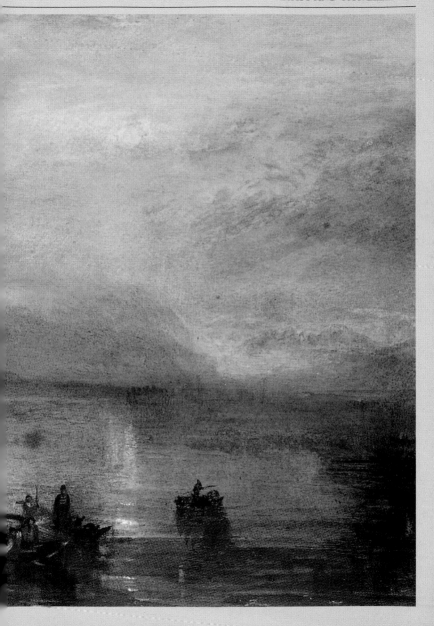

outset of his career, Italy had inspired and nourished his art, with classical literature furnishing him with an inexhaustible repertoire of themes.

Turner felt a kind of reverence for Rome as painted by Claude, but he also devoted careful study to John Robert Cozens' contemporary views. For many years, however, the only Italy he knew was the country he learnt second-hand through books and paintings: from 1793 to 1815, continuing hostilities between France and England precluded any opportunity to travel to Italy and satisfy his curiosity. And in 1802, when the Peace of Amiens was signed, it was to France that he went, only making one short excursion onto Italian soil to visit Valle d'Aosta. Turner's first proper visit to Italy was not until 1819, when the artist was forty-four. He only returned once to central Italy, preferring Venice and the Italian, Swiss and Austrian Alps. As far as Turner was concerned,

Above, a page from a sketchbook, with Turner's notes on his journey to Rome.

Italy was two countries: Rome and the South, and the Alps and Venice.

The reality of Rome

The image of Rome had threaded through the whole of the early part of Turner's life, but it was also his greatest misconception. He dreamed of it constantly and even painted it – even before his first visit – producing a number of watercolours for James Hakewill's *Picturesque Tour of Italy* (1818–20).

When he did finally reach Italy, Turner spent more than three months doggedly exploring every corner of Rome, neglecting the most elementary social niceties in the process. The delay may have intensified his longing for the place, but, if the truth be told, the visit did not afford Turner the pleasure he had anticipated. His subsequent neglect of Rome (which he never actually acknowledged) seems paradoxical, but may perhaps be explained in a number of ways. The Italy that Turner had imagined for almost thirty years, through his reading and appreciation of paintings, may have only corresponded very dimly to the Italy he encountered in 1819. In the 18th century, the British may have regarded themselves as the true heirs of ancient Rome, on the basis of their political system and prevailing moral values, but in terms of culture Britain and Italy were as

Below, sketches from engravings in John Warwick Smith's *Select Views in Italy*. Turner copied works like these to acquaint himself with Rome's most famous sights before his first visit in 1819. After this preparation, buildings like the Colosseum (watercolour, opposite below) would already be familiar when he painted them from life.

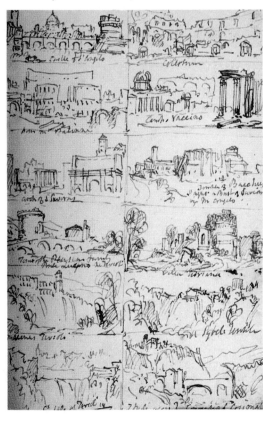

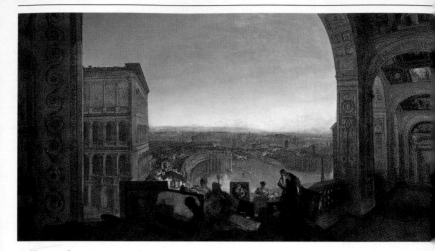

different from one another as they could be. To Turner's mind, the imaginary and the sublime were just as important as the works of classical writers and the great painters of the Renaissance and the 17th century. As further proof of his disenchantment, he only took a real interest in the Roman landscape on the occasion of that first visit in 1819, his second, in 1828, being devoted instead to society life and to paintings of interiors. If Turner worked with enthusiasm in Rome, it was probably because he was discovering the work of the old masters, rather than recording the scenery.

Shadows over Rome

Turner was disappointed with the light in Rome, and this (unavowed) disappointment contributed to his general disinterest. Although he had studied and copied Cozens' delicate contre-jours in Dr Monro's collection, in the company of Girtin, and had admired the subtle effects achieved by Claude and Richard Wilson, he was clearly disconcerted by the reality of Rome – the limpid landscapes, harsh light and sharply defined shadows. He also seems to have had his reservations about Naples, although he was probably imagining the city in 1817 when he drew Vesuvius (which he had never seen) from originals by James Hakewill.

His work, moreover, was poorly received. He completed three large paintings on Roman subjects in the 1820s – *Rome from the Vatican*, with its homage to Raphael, *The Bay of Baiae, with Apollo and the Sibyl*, and a *View of the Forum* – but none of these found a buyer. The architect Sir John Soane, for whom Turner painted another *View of the Forum*, turned the picture down, and after the 1828 trip, the works using Roman material only met with limited success. Nevertheless, many critics continued to praise Turner to the skies. In 1832, a critic from *The Morning Chronicle* wrote that Turner 'is a sort of Paganini, and performs wonders on a single string – is as astonishing with his chrome, as Paganini is with his chromatics'.

Matching the demands of Venice

It was in the northern part of the peninsula, in Venice, that Turner found real inspiration. The impression that

'You will have heard of Mr Turner's visit to Rome; he worked literally all day and night here, began eight or ten pictures and finished and exhibited three, all in about two months or a little more.'

The painter Charles Eastlake to a friend in Liverpool, 1819

Turner exhibited *Rome from the Vatican* (opposite) in 1820, for the 300th anniversary of the death of Raphael. Below, *Childe Harold's Pilgrimage – Italy* (1832) was inspired by Byron.

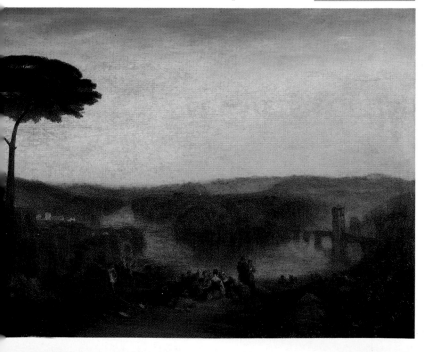

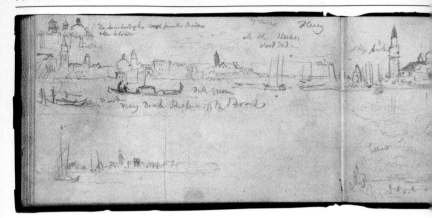

the lagoon made on Turner is equalled only by the impression he makes on us today as he continues to influence our own vision of Venice. Turner's Venice affects us profoundly, more so than Canaletto's or Guardi's or Bonington's. Rarely has a painter's art found such a perfect correlation as in this city, with its mists and its changing light, its reflected buildings shifting with every movement of the shimmering water, its tragic impression of decay mingled with pride. Venice offered Turner all his favourite themes – water, light, the dissolution of forms, the sense of the sublime, distance, the past, the importance of history – in infinite and ever-changing combinations.

Turner spent less time in Venice than in Rome, but having also spent less time imagining it, he was more deeply susceptible to its charms. His first visit, in 1819, was only of a few days' duration. The city, which had lost its independence to Napoleon and in 1815 had fallen under the control of the Austrian Empire, had suddenly grown in fame through the poetry of Lord Byron, who lived there from 1817 to 1820. Although Florence, Rome and Naples had been the primary attractions with foreign travellers visiting Italy, Venice now began to draw crowds of English and European tourists. Turner visited again in 1833, for ten days or so, and in 1840, for almost two weeks, during which

In the *Venice to Ancona* sketchbook, from his first trip to Venice in 1819, Turner sketched this silhouette of the city (above). Much of his time outdoors was spent making simple sketches like these. The son of his friend, the architect John Soane, reported in a letter of 1819 the response made by the painter to a group of fashionable young Englishmen who asked him why he did these drawings: 'he grunted...that it would take up too much time to colour in the open air – he could make 15 or 16 pencil sketches to one coloured, and then grunted his way home'.

time he worked tirelessly.

'The next time I met Turner was at Venice, in the Hotel Europa, where we sat opposite at meals and entered into conversation,' wrote William Callow in his *Memoirs*. 'One evening while I was enjoying a cigar in a gondola I saw in another one Turner sketching San Giorgio, brilliantly lit up by the setting sun. I felt quite ashamed of myself idling away the time whilst he was hard at work so late.' The anecdote demonstrates Turner's passionate determination to seize each moment of the day, each variation in the light as it played on the buildings and the sea. Turner's works are always accompanied by a wealth of notes of a literary, sentimental or philosophical nature, but this episode shows us the painter actually there, on the spot, face to face with his subject. The disappearance of the subject, in a formal sense, directly recalled the vanishing world that was Turner's experience of Venice.

•But there the water lay, no dead grey flat paint, but downright clear, playing, palpable surface, full of indefinite hue, and retiring as regularly and visibly back and far away, as if there had been objects all over it to tell the story by perspective. Now it is the doing of this which tries the painter, and it is his having done this which made me say...that "no man had ever painted the surface of calm water but Turner".•

John Ruskin, on Turner's Venice paintings, in *Modern Painters*

L eft, the cover of Turner's *Milan to Venice* sketchbook.

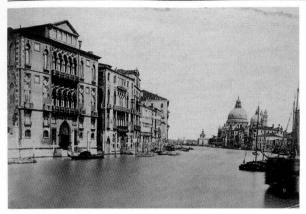

Evoking the passage of time

The importance of Venice in Turner's work can be measured first and foremost by the number of large paintings of Venice that he showed at the Royal Academy. Between 1833 and 1846, he exhibited more than twenty Venetian canvases, each of which was greeted with immense enthusiasm. The undeniable quality of the watercolours he painted while he was in Venice or after his return to London further demonstrates the close relationship that existed between the artist and the city. It was as if the work of Turner identified itself with Venice, and the city of Venice identified itself with his watercolours.

The formal aspects of Turner's work need to be considered in tandem with the artist's own feelings in the face of time passing. An awareness of transience, conveyed with grandeur in a painting commemorating the last voyage of *The Fighting 'Téméraire'*, completed in 1839–40, permeates his landscapes of the lagoon. And yet the diffused sense of time simply evaporating in exquisite visions of watery light, the unreality of the people housed in a landscape doomed to

While he was in Venice, Turner stayed at the luxurious Hotel Europa, which faced San Giorgio Maggiore, near St Mark's Square, and provided him with a number of remarkable views. In 1842, Turner exhibited a view of the Customs House whose title mentioned the hotel (*The Dogano, San Giorgio, Citella, from the Steps of the Europa*). Below, the Campanile, seen from the same room in the Europa. It was rarer for Turner to paint the interior of his room, as in this bold watercolour (opposite). Left, a photograph of the Grand Canal, *c.* 1860.

destruction, all the morbid aspects of the scene, cannot override the impression of wonder and awe that is the foundation of Turner's Venetian work.

In contrast to Rome, seen through Claude's magical prism, Turner only knew Venice through Canaletto and a handful of vedutistas, whose work tended towards precision rather than atmosphere, and towards the picturesque rather than the poetic. No artist before Turner had specifically set out to transform or idealize Venice; no classical culture had encumbered it with excessive baggage. The result was that Turner, far from being disappointed by the reality of Venice, felt completely free to approach it in his own way. He was not obliged to fill his landscapes with references to ancient history. At most he made brief allusions to Shakespeare's *Merchant of Venice* when he exhibited his *Scene – A Street in Venice* at the Royal Academy in 1837, and to Byron's *Childe Harold's Pilgrimage* in three pictures on that theme.

Overleaf: shown in 1841 with two other views of Venice, *The Ducal Palace* was well received by those very people who criticized Turner for his 'extravagances'. Writing in the *Athenaeum*, one critic declared: 'In these Venetian pictures it would be hard to exceed the clearness of air and water – the latter taking every passing reflection with a pellucid softness beyond the reach of meaner pencil.'

Pages 84–85: A view of Santa Maria della Salute, exhibited at the Academy in 1844.

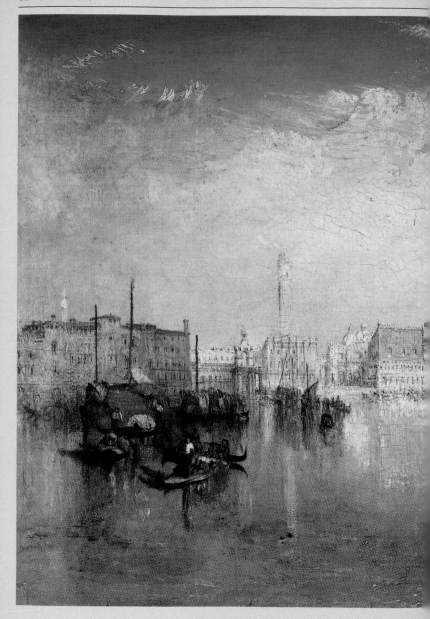

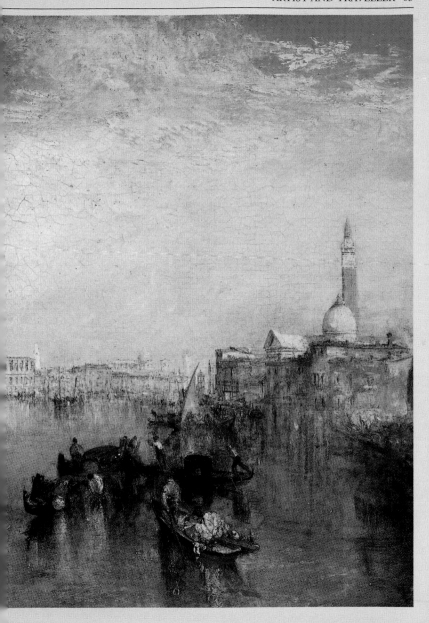

The spirit of France

Ruskin said of Turner that 'Of all foreign countries he has most entirely entered into the spirit of France.' When Turner first travelled to Europe, in 1802, he used France simply as a route to the Alps. On his way back, however, he spent more than a month in Paris, devoting much of September to studying the collections in the Louvre, which had recently been extended by the acquisition of works seized during the Napoleonic campaigns. He was particularly interested in Poussin and the Venetian artists, as well as Rembrandt, Watteau and Joseph Vernet, but paid strangely little attention to any of the works by Claude.

Turner also took advantage of his first stay in Paris to visit Jacques Louis David's studio, where he saw the artist's *Bonaparte at Mont St. Bernard*. On other occasions, he visited Pierre Narcisse Guérin and Eugène Delacroix, who was a connoisseur of English art with a particular fondness for Constable, a reader of Byron and friend of Richard Parkes Bonington, so therefore had

This watercolour from 1833 (above) shows the road between Mantes and Vernon, north-west of Paris. As in many of Turner's works devoted to the Seine, the landscape is highly animated. Our eyes are drawn to the passing carriages, the roadside stalls and the figures of the women and children – who almost appear to be dancing – rather than the river itself. People are important in this painting: it is often said that Turner neglects the human figure, but in fact it contributes to the overall balance of the majority of his compositions.

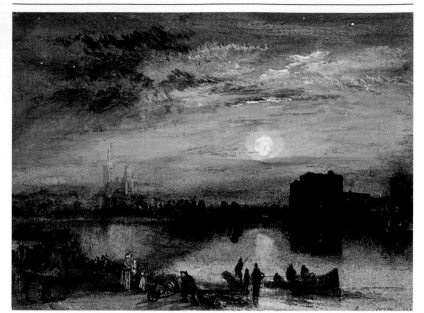

many good reasons for receiving Turner, whose work he also admired. However, the meeting seems to have proved disappointing for Delacroix: 'I remember having received him at my house just once when I was living in Quai Voltaire,' he records in his *Journal*. 'He made a very average impression: he looked like an English farmer, with his rather coarse black coat, his heavy shoes and his grim face.'

Along the Seine

The most remarkable journeys that Turner undertook in France, however, were those he devoted to exploring two of its rivers, the Seine and the Loire. On many occasions, notably in 1821, 1826, 1828, 1829 and 1832, the painter travelled up and down the Seine, exploring its banks as far as Troyes, covering hundreds of pages of his sketchbooks with sketches and notes, and accumulating watercolour studies. In 1834, he published a collection of twenty engravings on the subject and, the following year, a second series. These engravings, accompanied by a text by Leitch Ritchie, are reproduced

Above, *St Denis, Moonlight*, an uncharacteristically dark view of this town on the outskirts of Paris. The royal basilica (which lost its great tower in 1846) is visible on the left. Turner painted this watercolour in 1833, the year in which restoration work on the building began. At the same time he was also preparing his book on the rivers of France, and the vignettes for Sir Walter Scott's *The Life of Napoleon Buonaparte*.

in a series of volumes entitled *Turner's Annual Tour*, in which Turner offered up the fruits of his British and European travels to a wide and eager audience. Turner's works on the Seine are often highly coloured and strongly structured, and demonstrate the artist's intimate knowledge of the landscapes bordering the river.

On the banks of the Loire

In 1826, Turner spent two weeks travelling on the Loire aboard one of the river's newly introduced steamboats. From this vantage point, he could see the banks and sketch the river and the towns bordering it – Nantes, Angers, Saumur, Tours, Orléans – from a totally new perspective. The result was a remarkable collection of drawings and watercolours, together with a single oil painting, shown at the Royal Academy in 1829. The watercolours, whether finished paintings or sketches, are characterized by a watery brightness in which the forms become diluted and stretched; the scenes are bathed in blue light from which shades of grey radiate, the delicate effects sometimes streaked with a touch of yellow. The twenty-one engravings taken from these works were published in 1833 under the title *Wanderings by the Loire*. According to Leitch Ritchie, who wrote the text for the collection, 'The river Loire has peculiar

WANDE

This view of Nantes (below), with the Saint-Pierre-Saint-Paul Cathedral in the background, was the preparatory watercolour for the frontispiece to *Wanderings by the Loire*. It was one of a collection of seventeen drawings which John Ruskin bought in 1858 and later donated to the Ashmolean Museum in Oxford.

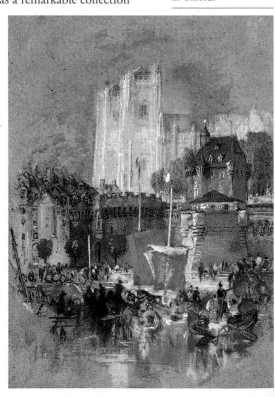

INGS BY THE LOIRE.

From Drawings

BY

M. W. TURNER, ESQ. R.A.

attractions for the English traveller. It waters those famous countries of Touraine and Anjou, where the bones of his ancestors are still to be found. Its banks are connected with numberless associations, both of history and romance.' The collection only met, however, with limited success. Other English artists such as Samuel Prout and William Callow were also producing paintings of the River Loire at the time, and in France, collections of engravings of provincial landscapes had become a commonplace since the appearance of Baron Taylor's *Voyages pittoresques*. Nevertheless, new editions of Turner's work have continued to appear, the most recent of these in 1990 – proof of their lasting interest.

When Turner travelled to Europe for the last time, in 1845, it was once again to visit France. He was received at the Château d'Eu by King Louis-Philippe, whom he had met in Twickenham in 1815, and whose arrival into Portsmouth he had painted the previous year. In 1832, he had also devoted an entire trip to visiting sites associated with the Napoleonic wars, to illustrate Sir Walter Scott's biography of Napoleon.

In northern Europe

Turner neglected southern Europe and never visited Spain, for example, which the British were just in the process of discovering. Instead, he travelled

This view of Saumur (below), seen from the Île d'Offard, was engraved from a watercolour of around 1828–30. It shows the Cessart bridge and, in the background, the castle – a landmark much admired by artists and previously painted by the Limbourg brothers in *Les Très Riches Heures du Duc de Berry* (early 15th century). Turner set out from Angers by diligence on the night of 5 October 1826 and spent only one day in Saumur. The sketches he made of the town are dotted about in the sketchbook he used for Nantes and Angers, as if to fill the spaces left after previous visits.

across the rest of Europe, including Austria, Denmark and Germany, often following the course of a river, such as the Rhine, the Moselle or the Meuse. On several occasions between 1817 and 1842, he visited what was then known as the Kingdom of the Netherlands, a country that, until 1830, comprised the present-day Netherlands, Belgium and Luxembourg. His

attraction for the northern countries owed much to his love of Flemish and Dutch painting, but also, at least as regards his first trip, to the site of Waterloo, which was his primary destination in 1817.

The reigning British monarch at the time, George III, was also Elector, and later King, of Hanover (many of his numerous children and grandchildren married German princes and princesses), but that fact does little to explain Turner's interest in Munich, Berlin, Dresden and Hamburg. Turner travelled throughout Germany, which was then divided into a number of kingdoms and principalities, even stopping off in Denmark on his way to Berlin. He visited art collections and monuments, taking copious notes and painting a series of watercolours. The Rhine was one of his favourite rivers. Celebrated by Byron, it offered an incredible variety of landscapes, from the Alpine stream to the majestic river that flowed through the flat, open country bordering the North Sea. Turner's German tours were not only an opportunity for the artist to paint landscapes for a keepsake book, some of which gave rise to large paintings like his *View of Cologne* and *Schloss Rosenau*, which he showed at the Royal Academy; they also enabled him to see for himself the places commemorated by Byron in *Childe Harold's Pilgrimage*. In addition, Turner expressed an interest

in Goethe, whom he respected both as a poet and a theoretician of colour.

His familiarity with Germanic culture and mythology is expressed in his painting *The Opening of the Wallhalla, 1842* – the first picture that the artist wished to exhibit in the country that inspired it. In 1845, Turner sent the painting to Munich, where it was hung in the Congress of European Art exhibition. The work was poorly received by German critics, who imagined that Turner had selected it simply to poke fun at their exhibition: 'Looking at this painting, it is impossible to believe that the artist ever painted a single decent thing or that he ever knew how to produce beautiful light and colour effects. His paintings are senseless.' The crowning irony was that the painting was only returned to the artist at his own expense, and arrived home stained.

In Germany, Turner found inspiration in the natural beauty of the Rhine (opposite, *Distant View of Coblenz and Ehrenbreitstein*), and also from contemporary events, such as *The Opening of the Wallhalla* (below), on 18 October 1842. Conceived by Ludwig I of Bavaria and designed by Leo von Klenze, this huge monument – named after the eternal resting place of great warriors in Norse mythology – was seen as a temple to the glories of Germany. It overlooked the Danube at Donaustauf.

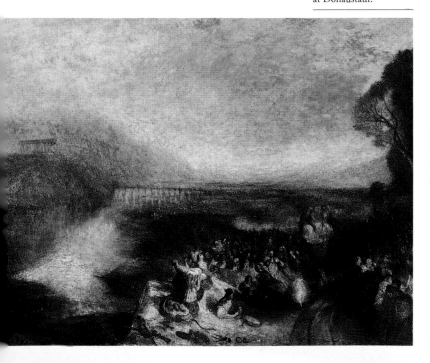

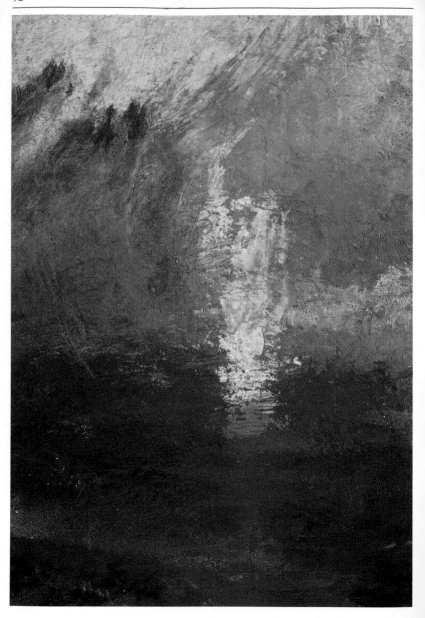

For more than a decade, beginning in 1830, Turner produced a series of extraordinary paintings that represented both a break with tradition and a radical transformation of artistic conventions. These were liquid, incandescent images in which forms disintegrated – disconcerting to many of his contemporaries, but demonstrating an incomparable mastery of colours.

CHAPTER 4

PAINTING ON FIRE

Turner was famed – and ridiculed (right, cartoon by Richard Doyle) – for his love of yellow. Sir George Beaumont said he suffered from jaundice, and Turner joked about it himself in a letter of 1830, asking a friend, to 'bottle up all the yellows which may be found straying out of the right way'. Opposite, a detail of *Slavers Throwing Overboard the Dead and Dying*.

THE MORNING CHRONICLE.

DREADFUL FIRE, and TOTAL DESRTUC-TION of BOTH HOUSES of PARLIAMENT.

Creativity and controversy

The first two decades of the 19th century were a period of intense activity for Turner, with exhibitions of his work at the Royal Academy and British Institution, as well as his own gallery, and extensive travelling in Britain and Europe. The 1820s, by contrast, mark a pause, at least in his public life: although he continued to paint and travel, Turner did not exhibit at the British Institution and cut back on his duties as teacher and Academician. The end of this decade ushered in an extraordinary period during which Turner was to paint some of his best-known works.

The 1830s and 1840s were at once the most creative and the most controversial years of his career. The material freedom he had enjoyed since the beginning

Above, a headline from the *Morning Chronicle* of 17 October 1834, the day after the Houses of Parliament fire. Below, *The Burning of the Houses of Parliament*. London's firemen (who belonged to private firms paid by insurers) worked all night to save the Great Hall and prevent the fire from spreading to Westminster Abbey, and crowds of people pressed into the Palace courtyard, disregarding the danger of the flames.

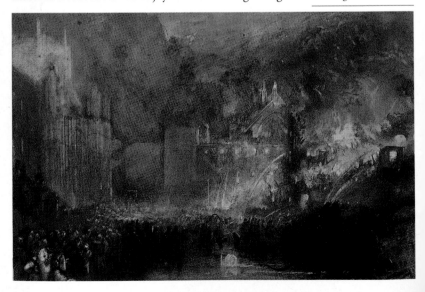

FRIDAY, OCTOBER 17

of the century and the immense stature that his successes had given him granted Turner licence to be as daring as he liked in his artistic experiments; but while he was producing genuine masterpieces, he also faced ever more frequent criticism: now that he had reached maturity, the moment of judgment had come. Turner felt a profound need to push his art to the limits, both by an even more violent use of incandescent and liquid effects, the contrast of glowing reds and areas of darkness, and by his choice of subjects, a disintegration of forms that shocked even some of his most loyal supporters.

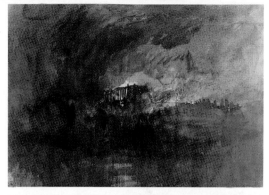

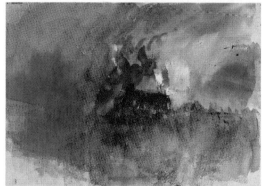

The burning of the Houses of Parliament

On 16 October 1834, along with many of his fellow Londoners, Turner watched all night as the Houses of Parliament burned down. It was a spectacle at once tragic and magnificent, a sublime conflagration that lit up the darkness and consumed in its path an ancient symbol of national liberty. The scene attracted thousands of onlookers, who watched with a mixture of horror and fascination, and painters were quick to exploit its artistic potential. Constable took up a position on Westminster Bridge, and Turner and others hired a boat and sailed up and down the Thames all night. Turner produced nine

A bove, two of the nine colour studies that immortalize the events of that night. Turner, the painter Clarkson Stanfield and a handful of students from the Academy hired a boat and sailed up and down the Thames, so – contrary to his usual practice – Turner may have produced these watercolours from life.

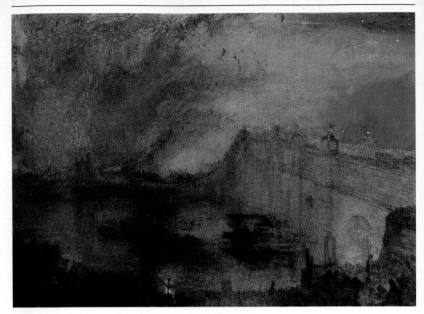

watercolours from different vantage points and two oil paintings, derived from these works, the following year. The one that hangs in Philadelphia's Art Gallery is particularly striking with its cold white bridge strongly contrasted against the brilliant yellows of the fire, and its scumbled blacks blotting out the reflections in the water and arcing over the fire like a rearing horse. The painting was virtually completed in the course of a day, in February 1835, while the canvas (on which Turner had barely begun working) was already hanging on a wall in the British Institution.

Painting as performance

On varnishing days, for some years now Turner had worked in full view of colleagues and interested spectators, who came in large numbers to witness the magical evolution of his paintings. This was almost 'performance art' in the modern sense of the term. The painter Edward Villiers Rippingille described one varnishing day at the British Institution:

‘The spectacle was one of surpassing though terrific splendour.... Westminster Bridge... was a curious spectacle, as the dark masses of individuals formed a striking contrast with the clean white stone of which it is built, and which stood out well and boldly in the clear moonlight.’
The Times,
17 October 1834

Above, *The Burning of the Houses of Lords and Commons*. This version shows the moment, at around 10 pm, when the fire fell back from the House of Commons chapel and began to move east.

'...it was quite necessary to make the best of his time, as the picture when sent in was a mere dab of several colours, and "without form and void", like chaos before the creation.... Etty was working by his side...and sometimes speaking to someone near him, after the approved manner of painters: but not so Turner; for the three hours I was there – and I understood it had been the same since he began in the morning – he never ceased to work, or even once looked or turned from the wall on which his picture hung.... A small box of colours, a few very small brushes, and a vial or two, were at his feet, very inconveniently placed; but his short figure, stooping, enabled him to reach what he wanted readily...he presented an aspect curious to all beholders, who whispered their remarks to each other, and quietly laughed to themselves. In one part of the mysterious proceedings Turner, who worked almost entirely with his palette knife, was observed to be rolling and spreading a lump of half-transparent stuff over his picture, the size of a finger in length and thickness.... Presently the work was finished: Turner gathered his tools together, put them into and shut up the box, and then, with his face still turned to the wall, and at the same distance from it, went sidling off, without speaking a word to anybody, and when he came to the staircase, in the centre of the room, hurried down as fast as he could. All looked with a half-wondering smile, and Maclise, who stood near, remarked, "There, that's masterly, he does not stop to look at his work; he knows it is done, and he is off."'

Below, *Turner on Varnishing Day*, by Charles West Cope. G. D. Leslie wrote: 'Turner went about from one to another of [his paintings] on the varnishing days piling on, mostly with the knife, all the brightest pigments he could lay his hands on...until they literally blazed with light and colour.' According to Leslie, other artists dreaded being exhibited alongside Turner – a prospect, apparently, as alarming as seeing their works hung next to an open window.

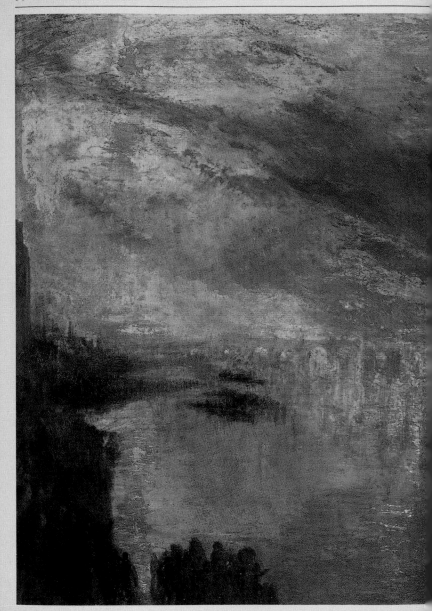

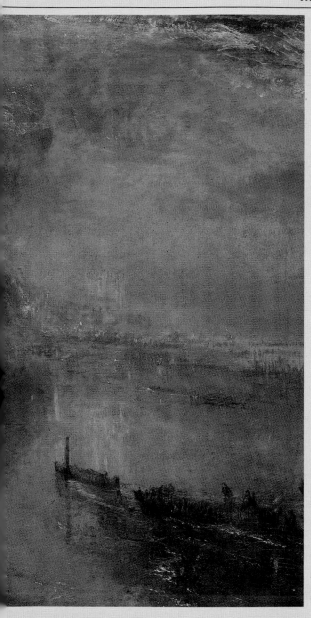

Left, the second oil version of *The Burning of the Houses of Lords and Commons*, which was shown at the Academy in 1835. Although the beauty of the painting and its relaxed style are clearly the work of an artist, and not someone merely recording events, certain details enable us to establish the precise viewpoint of the painting and the precise moment in time that it represents. The boat in the foreground, for instance, has been clearly identified as the small tug which, at around one o'clock in the morning, brought the Sun Fire Office's fire-float to the scene from Rotherhithe, so saving what remained of the majestic and intricate labyrinth of buildings that had served as the seat of Parliament since the 16th century. Some critics, however, drew attention to other details that Turner had modified or distorted – in particular, the direction of the flames – and described the picture as extravagant. *The Times* wrote that Turner's 'fondness for exaggeration led him into faults which nothing but his excellence in other respects could atone for'.

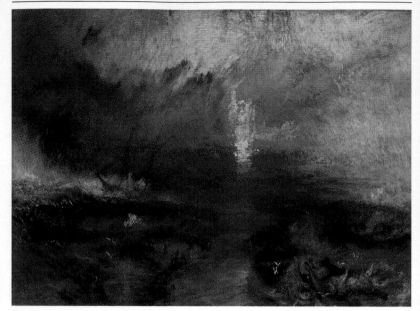

Disintegration and transformation

Whether their themes are industrial, as in the case of
Keelmen Heaving in Coals by Night, shown in 1835,
or maritime, as in *Rockets and Blue Lights* (1840), the
majority of works from this period are characterized by
a chaotic disintegration of forms and the transformative
effects of contrast and opposition. Whereas *Rockets and
Blue Lights* is a purely pictorial work, other compositions
tackle important political issues. In *Slavers Throwing
Overboard the Dead and Dying*, for example, painted the
same year, Turner found a way of treating a subject as
serious as the slave trade by dramatizing it in a visually
powerful image. It may seem strange to us today that
an artist so deeply engaged in aesthetic experiments
that isolated him from his public was also capable of
engaging his art in the service of politics. Following
the banning, on 25 March 1807, of the Atlantic trade
(whereby Africans were deported to the British colonies),
the British had signed a number of international treaties
denouncing clandestine trading and their fleet was given

*I believe, if I were
reduced to test Turner's
immortality upon any
single work, I should
choose this. Its daring
conception, ideal in
the highest sense of the
word, is based on the
purest truth....*
Ruskin on *Slavers
Throwing Overboard the
Dead and Dying* (above)

John Ruskin's father
purchased this
work as a gift for him
when he completed his
book *Modern Painters*.
Although Ruskin greatly
admired the painting,
he later admitted that it
was difficult to live with
such a subject, and he
tried (unsuccessfully) to
sell the work at auction.

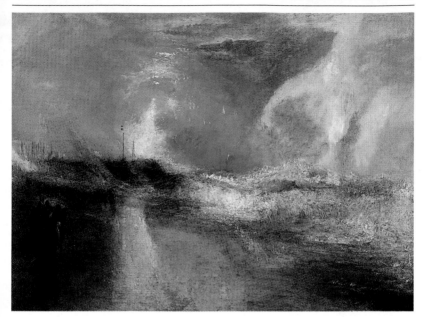

the right to search ships suspected of carrying Africans. The abolitionist movement was highly active in England – its leaders included some of Turner's patrons, such as the Earl of Carysfort, to whom the engraving entitled *The Deluge* was dedicated – and Britain was the first to abolish slavery in 1833 (followed by France in 1848, the Netherlands in 1861 and the United States in 1865).

Meditations on history

At the end of the decade, Turner, who was by now well into his sixties, also painted a number of pictures that look at historical events in a particular light. *The Fighting 'Téméraire' Tugged to her Last Berth to Be Broken Up, 1838* expresses at once the quintessence of his art as a colourist, the lessons he had learnt from Claude, his own predilection for skies, which he studied ceaselessly, and his ability to evoke a sense both of stasis and of movement.

The *Téméraire* was built in 1798 and its principal claim to fame was the heroic part that it had played in

A above, *Rockets and Blue Lights*. This work is sometimes presented as a pendant to *Slavers Throwing Overboard the Dead and Dying*, to which it provides a striking visual counterpoint. As blue and white as *Slavers* is yellow and red, the picture is as optimistic as the other is sombre. The painting's history has been eventful: in 1857, while it was on its way to Manchester, where it was due to be exhibited, the train that was transporting it was derailed, and over the following eighty years it changed hands more than twenty times.

the victory of the British fleet under Nelson at Trafalgar in 1805. While the French were firing at Nelson's flagship, the *Victory*, the *Téméraire* performed a particularly daring manoeuvre and successfully attacked the enemy ships from both flanks, the extraordinary temerity of its captain undoubtedly contributing to the British victory. Following the Napoleonic Wars, the huge ship was used as a receiving ship at Sheerness, before being sold with her masts removed – in contrast to Turner's depiction – in 1838.

If Turner was indeed depicting the ship being tugged to a breaker's yard, then he did not in fact produce an eyewitness account of the *Téméraire*'s last voyage, contrary to the assertions of his first biographer, Walter Thornbury. Nevertheless, he had observed similar scenes, in a number of ports and on all the great rivers of Europe. A gouache of 1830–32 shows a large ship on the Seine, between Quillebeuf and Villequier, being tugged

When *The Fighting 'Téméraire'* (below) was shown at the Academy in 1839, critics were unanimous in their praise. 'There is something in the contemplation of such a scene which affects us almost as deeply as the decay of an old human being,' said the *Morning Chronicle*. William Makepeace Thackeray called it 'as grand a painting as ever figured on the walls of any Academy, or came from the easel of any painter. ...He makes you see and think of a great deal more than the objects before you....'

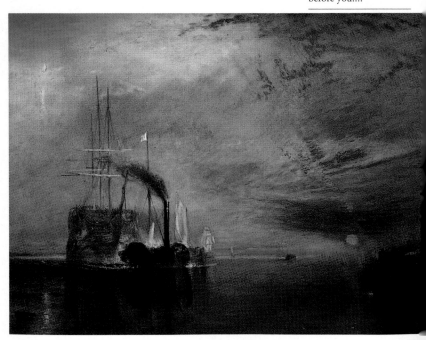

I differ most naturally with you – and no consideration of money or favour can induce me to lend my Destiny again

by a small paddle steamer. The great vessel is almost a ghost ship, its masts stripped of sails and all colour, while the whole body of the black tug seems to be glowing from the heat of its boilers, and its funnel is giving off nearly as much fire as smoke. A panoramic sunset floods the entire picture with light. Rarely has a work illustrated with such poignancy and simplicity the sense of time passing, and the vanishing of former glories, alongside the relentless activity of men and the brutal invasion of modernity.

The painting of the *Téméraire* was presented to the Royal Academy in 1839 and it moved the heart of the nation. Public and critics alike were touched by this vision of the majestic ship now fallen from glory, the pride of the seas being led to its destruction. The painting was hugely popular and throughout

Overleaf: *Peace – Burial at Sea*, painted in 1842.

the 19th century it inspired a constant flow of copies, engravings, poems and songs.

A tribute to Wilkie

Another masterpiece that handled similar themes – the frailty of human life and the passing of all things, all greatness and glory – was *Peace – Burial at Sea*, painted in 1842. The painting was a homage to the great genre painter of the early 19th century, Sir David Wilkie (1785–1841). Wilkie was famous throughout Europe, frequently outstripping even Turner in popularity. Although never really friends, the two men were bound by a mutual respect. In 1840, Wilkie went to the Holy Land, on what was both a spiritual quest and a search for new material. On his return journey, he died at sea, just off Gibraltar. Turner's painting of the artist's burial at sea wonderfully evokes the silence and spirit of contemplation reigning over the scene, its sense of fatality – without including a single human figure or focusing on any details of the action. The distance gives the scene the force of an event beyond human control, and the backlighting casts over it a Stygian gloom. A few weeks after finishing the work, Turner confided to a fellow artist, Clarkson Stanfield, that he would have liked to paint it darker still as a true expression of his grief.

Rain, Steam, and Speed

In 1844, Turner produced a work that came to occupy a central place in his oeuvre and in the history of European painting as a whole. Regarded as a manifesto of his art and as a symbol of the invasion of the modern world, *Rain, Steam, and Speed* is a painting that both represents and transcends its time. Since 1840, the railways had been a universal phenomenon, but one that was often ignored by artists – despite their reputation for being more attuned to the world around them than ordinary mortals. Only a few, and these on the whole well after Turner, dealt with the subject: German painter Carl Spitzweg imagined the train through the eyes of a mountain gnome, while French sculptor Bartholdi saw it as an object of fear to the nymphs of the forest.

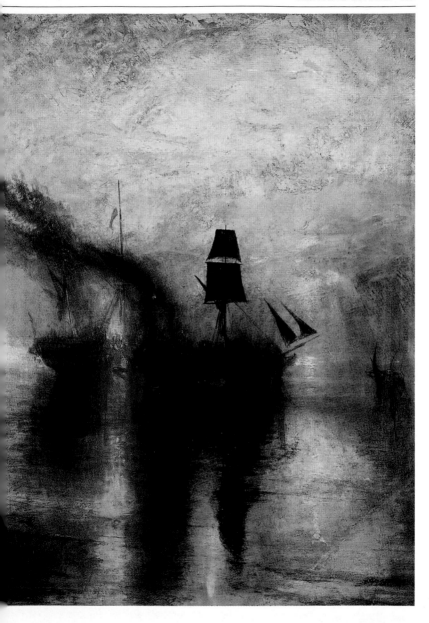

The Pre-Raphaelites, for their part, were sensitive to the atmosphere generated by new forms of public transport, their rapid spread and the congestion they caused. In 1862, the artist William Powell Frith painted a railway station as one of the new urban landmarks, depicting not the machine itself, not the concept of movement, but the architecture that served as a showcase and a framework for a new way of life.

Turner had already depicted early goods trains in 1823 in a harbour scene in his *Rivers of England* series. In *Rain, Steam, and Speed*, he was no longer concerned with representing engines or railways in physical terms: what he was seeking to do was to convey the sensations created by this new form of travel. There is no nostalgia here, no sentimentality, no appeal to a metaphorical mythology disturbed by modernity. The painter focuses on the impalpable, the immaterial, and the only extraneous addition is the minuscule outline of a hare running in front of the train – pointing up the contrast between the mechanical and natural worlds and providing a discreet metaphor for time passing. No other artist was capable of conveying this new physical phenomenon in such a way, the sensations it induced,

The locomotive painted by Turner in *Rain, Steam, and Speed* (above) in 1844 was a Luciole. Even faster engines, capable of attaining considerable speeds, were being developed around that time: in 1843, a top speed of 75 mph was recorded on the Great Western Railway from London to Bristol. Above left, the Liverpool to Manchester line, engraving after Thomas Talbot Bury, 1830.

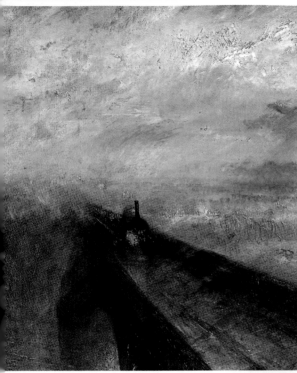

'It was a true cataclysm.... It could have been the setting for the end of the world. And through it all came the engine, twisting like the beast of the Apocalypse, opening its red glass eyes in the darkness and trailing the vertebrae of its carriages behind it, like an immense tail. It was a rapid sketch full of wild fury, no doubt, jumbling earth and sky in a single brush stroke, sheer extravagance, and yet the work of a crazy genius.'

Théophile Gautier, writing about *Rain, Steam, and Speed* in *Histoire du romantisme*

Below, a satire by G. A. Sala on the inconveniences of train travel, inspired by Turner's work.

the sense of speed. The notion of the sublime was no longer confined to natural phenomena (as it had been for artists for the past century), but incarnated in machines created by a humanity with god-like aspirations, whose new power it served to magnify. Turner's attention to light, colour and movement, even more than his attention to material objects, gave the train symbolic status.

Into the vortex

Turner's mature works also include a small group of paintings and watercolours that use circular compositions. Some of these

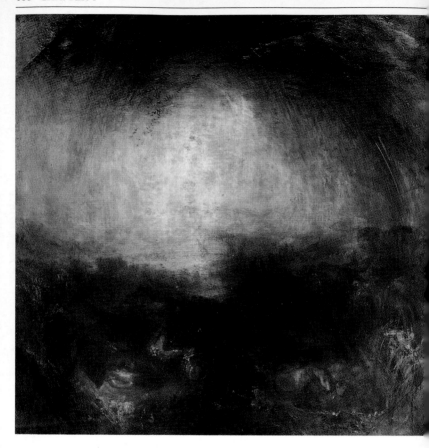

are clearly inscribed inside the geometric figure of a circle; others gather together colours and forms in a great swirling movement. In so far as these works (or the principal ones among them) seem to reflect a broader aspect of Turner's art, they merit consideration in a visual category of their own. Turner appears, in effect, to have conceived works like *Light and Colour (Goethe's Theory) – the Morning after the Deluge*, for example, or *War – The Exile and the Rock Limpet* as cosmogonies or studies of the origin of the universe, total works of art whose sunlike shape reveals their systematic construction.

Above, *Shade and Darkness – the Evening of the Deluge*, inspired by a poem by Thomas Gisborne and shown at the Academy in 1843: '...the giant framework floated, / The roused birds forsook their nightly shelters screaming, / And the beasts waded to the ark.'

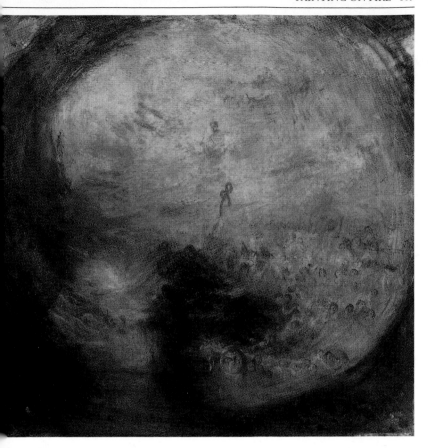

These famous compositions may be grouped together with more modest works such as *The Angel Standing in the Sun*, *Undine Giving the Ring to Massaniello*, *The Dawn of Christianity*, and several watercolours. Although not formally linked, all these works demonstrate Turner's aspiration to construct a theory of perception that takes account of the integral nature of the world.

Above, *Light and Colour (Goethe's Theory)* – the Morning after the Deluge, the pendant to *Shade and Darkness*. Charles Eastlake's translation of Goethe's *Farbenlehre*, called *Theory of Colours*, appeared in 1840, and Turner added his own (often critical) notes.

Turner died in a small house in Chelsea that he was renting under another name. The secrets of his private life now became public knowledge and a lengthy battle ensued regarding the details of his will. The artist had left strict instructions specifying what was to happen to his work, allocating a large part of his fortune to the funding of a museum and a charitable institution for fellow artists.

CHAPTER 5

TURNER'S LEGACY

Right, one of the rooms in the Turner Gallery, an adjunct to the National Gallery of British Art (now the Tate) created in 1910. The paintings were displayed on a patterned background. Despite discrepancies in the interpretation of his will, Turner's wish for the creation of a museum dedicated to his work had been respected. Opposite, a portrait of Turner by Ruskin, *c.* 1840.

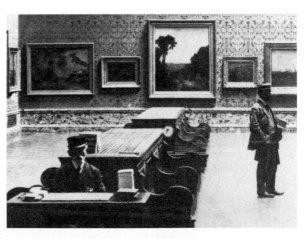

A secret life

Turner died on 19 December 1851, at the age of seventy-six, in a house in Chelsea facing the Thames. He had been suffering for some months from a heart condition. With his death, details emerged regarding another, more private, life that Turner had constructed for himself well away from the limelight and the fashionable society he frequented as an artist.

As early as 1833, he was renting rooms from the wife of a bargeman, Sophie Booth (1798–1875), in Margate, the seaside resort where he had spent a part of his childhood. His landlady was widowed soon after and subsequently became the painter's devoted companion. Their relationship continued for eighteen years, until Turner's death, unbeknown to any of his friends and acquaintances – a part of his life that he succeeded in keeping entirely separate from the obligations imposed by his celebrity. This taste for secrecy was not new, since Turner had already had two daughters from an earlier relationship with the widow of a musician and composer, Sarah Danby, who was some ten years his senior, but outlived him by a further ten years. This relationship lasted almost fifteen years, but was never made official and was broken off for reasons that are

Above, George Jones, *Turner's Coffin in his Gallery at Queen Anne Street, c.* 1852. The day after he died, Turner's body was taken to Queen Anne Street and placed in the centre of the artist's gallery, and a small group (mainly of artist friends) held a vigil round the coffin. The funeral cortège then proceeded to St Paul's Cathedral, where a large gathering was present as Turner's remains were placed in the crypt, near the tombs of Sir Joshua Reynolds and Sir Thomas Lawrence. Immediately after the ceremony, Turner's executors returned to the gallery to hear the reading of his will.

Left, *Reclining Nude on a Bed*, one of the many erotic drawings and watercolours discovered by Ruskin while he was classifying Turner's works following the artist's death. Ruskin tried to conceal these works, convinced that they were 'assuredly drawn under a certain condition of insanity'. For many years, it was assumed that most of them had been burnt, but it appears today that a considerable number – just over a hundred – have survived as part of the Tate bequest.

unclear. It only came to light as a result of the artist's will, in which he expressed his intention to pay an allowance, of albeit modest proportions, to this family waiting discreetly in the wings. In fact the main substance of his will concerned neither his family nor his friends, but an altogether separate matter.

A home for his work

Few artists have put so much effort into preparing for posterity. The idea may seem relatively commonplace to us today, but in Turner's time it was exceptional. Turner's complex will sets out his wish for a gallery dedicated to his work to be created after his death. The money for the project was to come from the sale of his various properties and personal effects. The sums obtained, he wrote, were to be used for 'the erection of the gallery to hold my pictures, and places, houses or apartments for

Above, a detail from *Crossing the Brook*, 1815. Some commentators have identified these two figures as Turner's two daughters – the revelation of whose existence was one of the more surprising aspects of the artist's will.

one, two, three, or more persons, according to circumstances or means which my executors may find expedient...to keep my pictures together, so that they may be...viewed gratuitously'.

At the same time, he also wished to set up a charitable institution for 'poor and decayed male artists born in England and of English parents only and lawful issue'. Despite the substantial additional sums bequeathed by the painter, it proved impossible to meet his wishes in full because of disagreements surrounding the execution of his will and lawsuits brought by his heirs. When the awards were made, London's National Gallery was assigned the task of establishing in perpetuity a gallery entirely dedicated to Turner's art, which meant housing some three hundred finished paintings, and around twenty thousand drawings and sketches.

One of the artist's other wishes was to see his works compared with those of his 'master': to this effect, he wished for two of his own paintings, *Dido Building Carthage* and *Sun Rising through Vapour*, to be placed in perpetuity opposite two works by Claude, *Seaport with the Embarkation of the Queen of Sheba* and *The Mill (Landscape with the Marriage of Isaac and Rebecca)*. This wish continues to be respected to this day.

Ruskin: Turner's champion

Probably the most notable and active of Turner's admirers, at the time of his death, was John Ruskin. The major enterprise of consolidating the artist's reputation both before and after his death was largely orchestrated by Ruskin. In 1856, he proposed a plan for classifying and studying all Turner's drawings and sketches and, the following year, he published his *Notes on the Turner Gallery*. During the winter of 1857–58, Ruskin examined each of Turner's works – and, in the process, altered his conclusions regarding Turner's art. Following the appearance of the final volume of *Modern Painters* in 1860, Ruskin's writings on Turner became more intermittent, but he nevertheless continued to acquire the artist's works, which he later donated to two museums – the Ashmolean, in Oxford, where he had studied, and the Fitzwilliam Museum in Cambridge.

Below, *Dido Building Carthage* and *Sun Rising through Vapour* hang opposite two paintings by Claude in an octagonal room in the National Gallery. Since 1987, the majority of Turner's works have been held in a special wing of Tate Britain – the Clore Gallery, named after Turner's patron Sir Charles Clore – but a few remain in the National Gallery after the artist's oeuvre was divided between the two institutions in 1954.

Opposite, an extract from Turner's will.

*executors and Trustees of this my last Will and Testament and I do hereby
revoke annul and make void all former or other Will or Wills by me at any
time heretofore made and executed and do declare this alone to be and contain
my last Will and Testament written and contained in eight sheets of paper
to the seven first sheets of which I have set my hand and to the eighth
and last I have set and subscribed my hand and seal this tenth
day of June — in the year of our Lord One thousand eight hundred
and thirty one*

*Signed Sealed Published and Declared
by the within named Joseph Mallord William Turner
as and for his last Will and Testament in the
presence of us who at his request in his presence
and in the presence of each other have subscribed
our names as witnesses thereto*

Joseph Mallord Wm Turner

*Geo Cobb Clements Inn
John Saxon Bruton Somerset
Charles Tull Winchester Row London*

Overleaf: King George V and Queen Mary opening the rooms devoted to contemporary foreign art at the Tate Gallery in 1926, as painted by Sir John Lavery. The ceremony was held in one of the Turner rooms. These were financed some decades earlier by Joseph Duveen, a leading art dealer of the 1900s, whose business mainly depended on the sale of 18th-century English paintings to wealthy American families. In Lavery's background, *Snow Storm: Hannibal and his Army Crossing the Alps* (centre) and *Christ and the Woman of Samaria* (upper left) can be easily identified.

In 1878, he published a new set of *Notes on Turner* to coincide with the presentation of his own collection to the Fine Art Society in Bond Street. Before the onset of the insanity that darkened his final years, Ruskin devoted more and more of his time to teaching. His fascination for the work of Turner, though diminished by the discovery of the artist's erotic sketchbooks, continued until his death: 'As in my own advancing life I learn more of the laws of noble art, I recognize faults in Turner to which once I was blind; but only as I recognize also powers which my boy's enthusiasm did but disgrace by its advocacy.'

The sketchbooks

Turner's sketchbooks, some three hundred in total, occupy a special place among the works bequeathed to the nation. They were labelled and indexed, but also for the most part dismantled by Ruskin, in an endeavour to extract those works suitable for public viewing. At the beginning of the 20th century, Alexander Joseph Finberg took on the considerable task of cataloguing these drawings.

What is striking about this huge collection is the unbelievable variety of techniques, subjects and styles that it encompasses, from rapid jottings to highly elaborate studies. The sketchbooks, most of which are now available online in digital form, are an almost inexhaustible source of information regarding Turner and his work. They show the heart of the creative process and are a vitally important way of retracing the artist's travels, an open book that, thanks to its lengthy chronology (from 1789 to 1845), reveals both the painter's habitual practices and the ways in

The fact that a large part of Turner's oeuvre is located in one place allows the stages of his creative process to be studied. This helps us to understand the artist's aims, and to recognize points where he diverges from his usual practices. *Calais Pier* (1803; opposite above) can be linked with a series of works on paper, ranging from simple colour tests like the one below, to pencil studies like the one opposite, below.

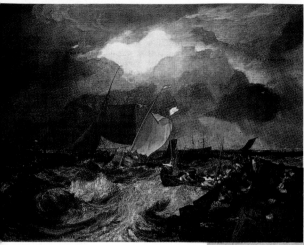

Turner's wish for the bulk of his sketchbooks to be preserved has had implications for the interpretation – even over-interpretation – of his work. Twentieth-century art historians have sometimes treated pages that the artist has simply coloured (perhaps to gauge a

which he broke away from them. Turner rarely used his sketchbooks in ordinary daily life, but he had them with him constantly when he was travelling. Quick to take advantage of technical innovations, he readily abandoned the heavy large-format sketchbooks common in the 18th century in favour of the light and flexible ones, often smaller in size, which were developed by paper manufacturers such as James Whatman. His sketchbooks were not an illustrated journal, but rather a collection of forms and themes grouped in series. Some of them only contain figures; others are dedicated to the preparation of a particular painting such as *Calais Pier*; still others, like the *Studies in the Louvre* sketchbook from 1802, served as a record and a reminder.

No artist before Turner had ever succeeded in creating a gallery where the bulk of his work would be conserved, and Turner's example had a profound influence on succeeding generations of painters.

particular colour effect) as if they were finished studies. The increasing popularity of the sketch since the mid-18th century has only served to focus even more attention on such preliminary studies.

Posthumous influence

There were a great many people who collected Turner's works throughout the 19th century, but the artist's influence on his contemporaries is less immediately obvious. Constable made an immediate impression on European art, in particular after taking part in the Paris Salon of 1824, but the response to Turner's work was slower and less spectacular when it came. It was not until a number of French painters – the Impressionists are those most regularly mentioned – visited London in the 1870s that Europe's attention was drawn to his startling pictorial innovations.

Camille Pissarro and Claude Monet were certainly impressed by Turner's audacious experiments, but it was in an artist like Félix Ziem (1821–1911) that Turner found a true disciple. Ziem's landscapes of Venice and Provence demonstrate the undeniable influence of the great painter, and a number of pastiches of Turner's works are attributed to him.

Below, *The Turner Gallery* by Bertha Mary Garnett, 1883. At the end of the 19th century, Turner's paintings were displayed close together (as here), but after the opening of the Clore Gallery, they were hung in a more relaxed manner.

Turner's experiments with light and colour influenced a great many artists from the end of the 19th century onwards, and gave rise to a number of quasi-pastiches, such as *Venice* (1903) by British-born American Thomas Moran (opposite).

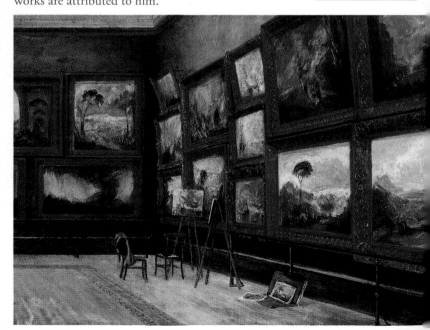

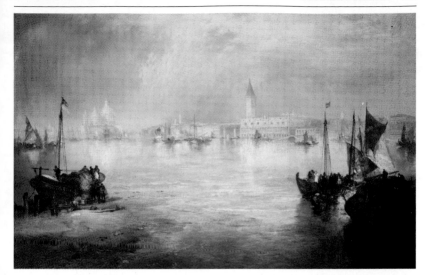

Turner's influence was more evident in Britain and the USA. From the 1820s, John Martin (1789–1854) imitated the spirit of his historical landscapes in paintings that depict Turner's most grandiose of scenes. An engraver by training, Martin used his own engravings as a basis for his paintings, and his visions of heaven and hell in extravagant settings achieved enormous success, making Martin one of the most popular artists of his day. Through the intermediary of his disciples, Turner remains today an inspiration to a cinematographic tradition that stretches from Cecil B. De Mille to *Lord of the Rings*.

A number of less famous artists also adopted some of Turner's more spectacular techniques. In the United States, Thomas Cole (1801–48) and later the artists of the Hudson River School, such as Frederic Edwin Church (1826–1900), developed a vision of nature that was both Claudian and sublime and unquestionably derived from Turner. Later still, Thomas Moran (1837–1926), who resolved to become a painter after leafing through a collection of engravings after Turner, explored the same principles in his depictions of the vast landscapes of the American West.

Overleaf: (left) James Whistler, *Grey and Silver: Chelsea Wharf*; (top right) Turner, *Sun Setting Over a Lake*; (bottom right) Claude Monet, *Impression: Sunrise*. Turner's work served as a kind of benchmark for many artists and critics at the end of the 19th century. Comparison of some paintings by Whistler and Monet with Turner's work can produce striking similarities but conclusions should not be drawn too hastily. Although they were powerfully attracted by Turner's work, these painters also wrestled to free themselves of his influence and sometimes even went so far as to deny their aesthetic debt to him.

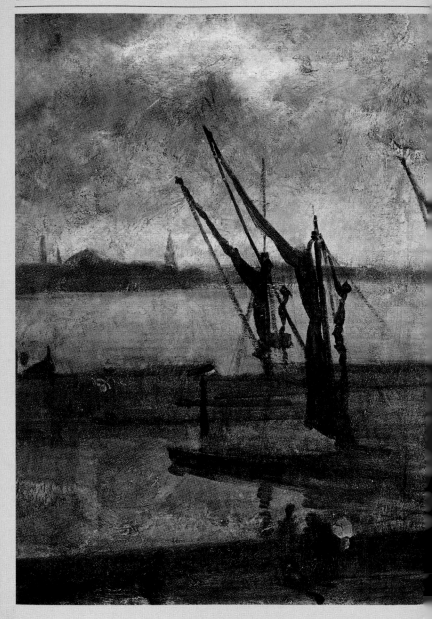

Turner's 'abstraction'

Long after Turner's death, critics were still debating one of the fundamental issues arising from his body of work – the question of abstraction. Indeed, several dozen of his works, most of them held at the Tate, have a quality that critics have variously described as 'abstract', or 'sketchy', or even 'unfinished'.

In the mid-20th century, the champions of the abstract avant-garde cast a retrospective look at the work of certain great artists. Finding themselves the object of criticism, incomprehension and even downright contempt, they enlisted the most diverse names from among these artists in support of their cause. Using a combination of subtle reasoning and ingenious connections, they created a history of art that was woven together from long and

●Turner's method was to float-in his broken colours, while the paper was wet, and my late master [W. L. Leitch] ...told me that he once saw Turner working, and this was on watercolour drawings, several of which were in progress at the same time! Mr Leitch said he stretched the paper on boards and, after plunging them into water, he dropped the colours onto the paper while it was wet, making marblings and gradations throughout the work. His completing progress was marvellously rapid, for he indicated his masses and incidents, took out half-lights, scraped out high-lights and dragged, hatched and stippled until the design was finished....●

James Orrock

Above and below, experiments with colour washes.

surprising genealogies stemming from the old masters, some of whom, like Piero della Francesca, allowed them to establish a majestic ancestry for the works of geometric abstraction. Turner's work was seen as providing the starting point for an organic dissolution that was close in nature to the lyrical experiments conducted by the great abstract artists of the second half of the 20th century. Such a notion, however, needs to be

Below, *Landscape with Water*, c. 1840–45. In the 1840s, Turner painted some thirty works that remain mysteriously 'unfinished' – 'abstract', as some viewers would describe them.

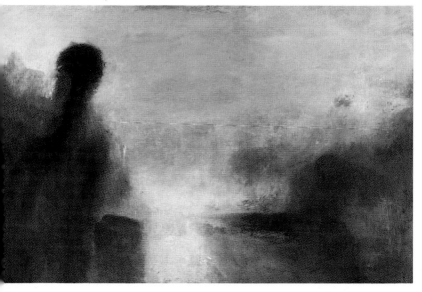

treated with caution. When we look carefully at Turner's works, we can see that even in the most stripped down of forms the artist is still determinedly pursuing his investigations into light, atmospheric forces and colour combinations. He may abandon form and line; but to argue the absence of a subject is more problematic. If some of his works appear at first sight to lack structure, or even a subject, with closer study we can identify, even in these, one or other of the landscapes treated elsewhere. In fact, in these watercolours, Turner works by subtraction rather than abstraction, as if he were removing the representation of solid elements from a landscape in order simply to retain the colours and the

❛...To entirely finished work, a certain degree of indistinctness is indispensable....
The strokes of paint, examined closely, must be confused, odd, incomprehensible; ...and if we can make anything of them quite out, that part of the drawing is wrong or incomplete.❜
John Ruskin, 'Of Turnerian Mystery', from *Modern Painters*

effects of the light, the phenomena of rain, mist and vapour. At no time does he seek to assemble areas of colour or geometric forms in an arrangement that is purely self-referential. Landscape remains the starting point; the painter's goal is to represent it. These unusual works, which were not intended to be shown, demonstrate, moreover, a clear relationship with the works that were intended for public display.

The dilution of painting

Turner followed the same unwavering course from the 1830s right up until his death. All his works, both private and public, testify to the same carefully calculated and single-minded endeavour – to represent places in terms of their colour and light, the atmosphere particular to them rather than the precise forms that constitute them. In this, Turner's painting was fed by other sources, his countless watercolours inevitably influencing the less spontaneous practice of working in oils.

The painter's recourse to watercolour should be regarded in the true sense of the term as an act of dilution. It was the same effect that Turner sought to achieve in some of his oil paintings, in which the dissolution of forms is as striking as the precise treatment of texture. The artist's attention to the minutest variations in these works gives his material a rare density, because of which (or despite which) the impression he tends to create is of a fugitive reality. In this respect, Turner was participating in the gradual reappraisal of the whole notion of the 'subject'. Its components, history or landscape, can be read as separate. While continuing to represent fragments of the real, light, line and colour are all moving away from one another. In the century that followed, the final links would be severed, and rendered meaningless, so that each element gained the aesthetic autonomy of a whole.

An exceptional figure

Among the great artists who have left their mark on the history of European art, J. M. W. Turner remains a strange exception. Achieving recognition as a very young

Above, *Landscape with Distant River and Bay*, c. 1835–40. The painting was bought by French industrialist Camille Groult in around 1880, at a time when few of Turner's works were circulating on the art market.

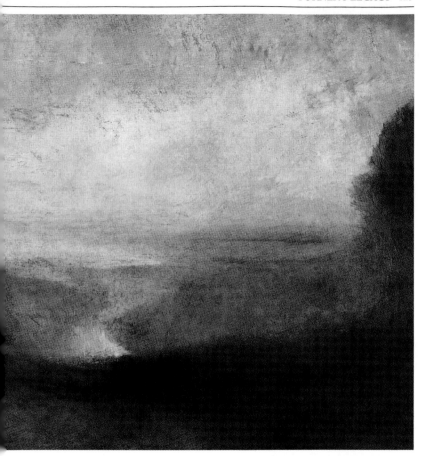

man, but misunderstood in his old age, famous but lacking real artistic successors, classical in his training, sensitive to the hierarchy of styles and institutions, but regularly disregarding it, he contradicts the romantic image of the artist. He is, moreover, frequently admired for the physical qualities of his work, although his entire output is nourished by history and poetry. Surprisingly, it was by taking his art to the limits of its traditions that he appeared to break the most basic rules of Western painting.

Overleaf: a portrait of Turner – probably drawn with the aid of a device called a physionotrace – by Cornelius Varley, c. 1815–20. The whole essence of the artist's creative spirit seems to be expressed in these gazing eyes.

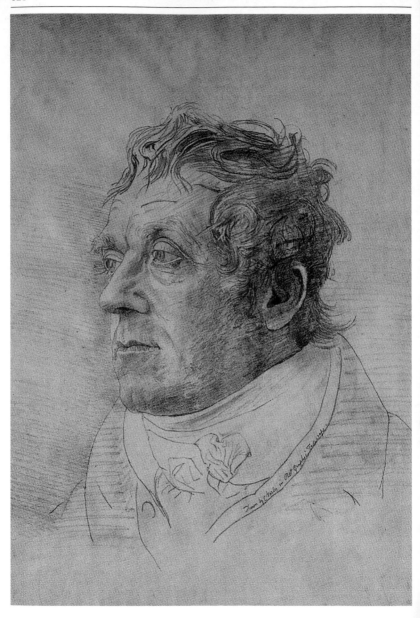

DOCUMENTS

Monday 18 Day of Dec' 18 __

Admit to the Lecture this Evening

C Turner

ROYAL
ACADEMY
LONDON

J M W Turner R.A

The Lecture will begin at Eight o'Clock.

In the master's studio

Turner had a longstanding reputation as a 'magician with colour', and his paintings display such skilled handling of light that their creation does indeed seem more closely allied with magic than with technique. In 1851, F. E. Trimmer, the son of Reverend Henry Scott Trimmer, one of Turner's oldest friends, visited Turner's studio for the first time, just a few days after the artist's death. His description provides a valuable record of Turner's preferred working environment and the tools and methods he used.

This [place], during his lifetime, had been enshrined in mystery, and the object of profound speculation. What would his brother-artists have given some thirty years before to have forced an entrance when Turner was at the height of his fame? Often when shown into his gallery had I seen him emerge from that hidden recess. The august retreat was now thrown open; I entered. His gloves and neckhandkerchief lay on a circular table, which had in the middle a raised box (with a circle in the centre) with side compartments; a good contrivance for an artist, though I had never seen one of the kind before. In the centre were his colours, the great object of my attraction. I remember, on my father's observing to Turner that nothing was to be done without ultramarine, his saying that cobalt was good enough for him; and cobalt to be sure there was, but also several bottles of ultramarine of various depths; and smalts of various intensities, of which I think he made great use. There was also some verditer.

The next object of interest was the white; there was a large bottle of blanc d'argent, and another of flake white. Before making this inspection I had observed that Turner used silver white. His yellow pigments consisted of a large bottle of chrome. There was also a bottle of tincture of rhubarb and some iodine, but whether for artistic or medicinal use I cannot say. Subsequently I was told by his housekeeper that ultramarine was employed by him very sparingly, and that smalt and cobalt were his usual blues. She was in the habit of setting Turner's palette. The palette – at least that in use, for he possessed two large splendid ones – was a homely piece of square wood, with a hole for the thumb. Grinding colours on a slab was not his practice, and his dry colours were rubbed on the palette with cold-drawn oil. The colours were mixed daily, and he was very particular as to the operation. If they were not to his mind, he would say to Mrs Danby, 'Can't you set a palette better than this?' Like Wilson, Turner

used gamboge; simply pounded and mixed with linseed cold-drawn oil.

His brushes were of the humblest description, mostly round hog's tools, and some flat. He was said to use very short handles, which might have been the case with his water colours; but I observed one very long-handled brush, with which I have no doubt he put in the effective touches in his late pictures. According to his housekeeper, he used the long brush exclusively for the rigging of ships, &c. However, there were a great many long-haired sables, which could not have been all employed for rigging. She also said that he used camel's hair for his oil pictures; and formerly he showed my father some Chinese brushes he was in the habit of using. When he had nearly finished a picture, she said, he took it to the end of his long gallery, and there put in the last touches.

I next inspected his travelling-box. Had I been asked to guess his travelling library, I should have said Young's *Night Thoughts* and Isaak Walton; and there they were, together with some inferior translation of Horace. His library was select, but it showed the man. A red morocco pocket-book, from the wear and tear it exhibited, one might have imagined to have been his companion through life. There were cakes of water colour fastened on a leaf, the centres of which were worn away; the commonest colours, and one being a cake of verditer; one or two sable brushes and lead pencils, not in wood, with which he seemed to have drawn outlines in his sketch-book. These consisted of a few lines which he used to say no one could make out but himself. I have some doubt if he could have made them out himself without the assistance of other drawings; and he seems to have purchased detail views of foreign scenery, of which there was a large assortment well thumbed; the drudgery of the art, of which master minds avail themselves.

There is no doubt that in his early pictures he used wax, from their having turned yellow; there was a jar of wax melted with rose madder and also with blue, which must have been used very recently, though it might have been for water colours. There was also a bureau of old colours and oils, which I looked over very carefully; a bottle of spirit varnish and a preparation of tar, tubes of magilp, old bladders of raw umber and other dark earths.

The above, with numerous unframed pictures around the apartment, were the contents of his painting-room, which had no skylight. It had been originally the drawing-room, and had a good north light, with two windows.

I must confess that a deep melancholy pervaded me as I made this inspection. Till of late years I had been in the habit of entering the house from my childhood; the owner was no more: he stood alone in the world, and his race was extinct.

F. E. Trimmer, 1851,
from Walter Thornbury,
*The Life of J. M. W. Turner,
R.A.*, vol. 1, London, 1862

Below, *Norham Castle on the River Tweed*, an engraving by Charles Turner after J. M. W. Turner, 1816.

From Turner's pen

Although nothing but brief extracts survive from Turner's long poem The Fallacies of Hope, *his letters and the brief notes written in his travel diaries give a flavour of the artist's everyday life. In a style that is often awkward, even abrupt, with erratic spelling and grammar, these writings paint a portrait of a man who was diligent, unpretentious, warm and direct, gruff at times, but also loyal and open with those he wrote to. He was also capable of showing great delicacy and discretion when difficult circumstances required it.*

'The ride is delightful'

Tuesday 31 [July]. set off after breakfast for Chirk Castle 7 miles pass'd thro' Chirk small village on an emminence the Castle belongs to Mr Middleton – is of Stone & nearly a quadrangle each side has three round towers embattled. In the windows & entrance the Gothick is preserved but within every Room is modernized – one of them is very spacious – Furniture all modern, Pictures good for nothing – the views from the windows are spacious & grand particularly – towards Winstay where the House appears very conspicuous. One side of the Quadrangle is of ancient date – the other of more modern being rebuilt by Sir Wm Middleton in 1636 as the stone specifies. ...The Views from the House are rich & grand – the Bath is well situated in a Valley about a qr of a Mile from the House & a spacious piece of water near it formed from the Bed of the old River is a fine object.... From Ruabon to Llangollen the ride is delightful, about 2 Ms. from Ruabon the eye is caught wth a beautiful object on descending a hill. The winding of the Dee across which the pont Newydd a noted stone bridge of 3 arches near wch the rocky & diversifyd Scenery of the romantic country – the perpetual rushing of the stream – over its rocky bed – is truly a delightful scene...

Extract from a travel diary, Wales, 1792

'Do as you think fit'

...may I ask once more 'am I to put out the cloud in the Picture of Bonneville'. If you can drop me a line decide[d]ly yes or no this Evening or tomorrow Morning it shall be as you wish.

Letter to Samuel Dobree, 30 June 1804

You will find that I have sent you all & have added the small picture of Margate which you appeared to like – your acceptance of it, and to allow it always to remain in your Eye as a small

remembrance of respect will be very pleasant to me, and altho it accompanies the *Boats Going Out With Cables*, consider it not as its make-weight – as to price, on that head I leave it entirely unto you, for you know my feelings and opinion on that score – therefore do as you think fit....

Letter to Samuel Dobree,
1 July 1804

'A large Tree would destroy the character!'

First let me thank you for the Sausages and Hare. They were very good indeed. As to the Oxford [picture], I understood you that Mr Pye would have it immediately after the High St should be finish'd. Therefore I began it at Xmas. But respecting the venerable Oak or Elm you rather puzzle me. If you wish either say *so* and it shall be done, but fancy to yourself how a large Tree would destroy the character! That *burst* of flat country with uninterrupted horizontal lines throughout the Picture as seen from the spot we took it from!

Letter to James Wyatt,
6 March 1812

'A plunge into the sea'

Two months nearly in getting to this Terra Pictura, *and at work*; but the length of time is my own fault. I must see the South of France, which almost knocked me up, the heat was so intense, particularly at Nismes and Avignon; and until I got a plunge in the sea at Marseilles, I felt so weak that nothing but the change of scene kept me onwards to my distant point.

Letter to George Jones,
13 October 1828

A visit to the Sistine Chapel

I have but little to tell you in the way of Art and that little but ill calculated to give you pleasure. The Sistine Chapel Sybils and Prophets of the ceiling are as grand magnificent and overwhelming to contemplating as ever, but the Last Judgement has suffer'd much by scraping and cleaning.... And it will distress you to hear that a Canopy (for the Host, the Chapel being now fitted up for divine service) is fixed by 4 hoops in the Picture....

Letter to Sir Thomas Lawrence,
27 November 1828

On the way home

This extract is taken from a letter in which Turner tells the tale of his journey home from Rome in the middle of winter; he also expresses anxiety about the pictures he has sent from Rome to London, before explaining the delays and harsh weather conditions that dogged his journey.

...we never could keep warm or make our day's distance good, the places we put up at proved all bad till Firenzola being even the worst for the down diligence people had devoured everything eatable (Beds none) ...crossed Mont Cenis on a sledge – bivouaced in the snow with fire lighted for 3 Hours on Mont Tarate while the diligence was righted and dug out, for a Bank of Snow saved it from upsetting – and in the same night we were again turned out to walk up to our knees in new fallen drift to get assistance to dig a channel thro' it for the coach, so that from Foligno to within 20 miles of Paris I never saw the road but snow!

Letter to Charles Lock Eastlake,
16 February 1829

A response to Ruskin

In October 1836, Blackwood's Magazine *printed a damning critique of Turner's* Juliet and Her Nurse, *which so incensed the young Ruskin that he wrote a vivid counterattack in praise of the painting, comparing its portrayal of the Venetian mists to 'souls of the mighty dead breathed out of the tombs of Italy into the blue of her bright heaven'. However, Ruskin first submitted his essay to Turner, who dissuaded him from submitting it.*

My Dear Sir

I beg to thank you for your zeal, kindness, and the trouble you have taken in my behalf in regard of the criticism of Blackwoods Mag for Oc[tober] respecting my works, but I never move in these matters. They are of no import save mischief....

A barrel of herrings

Your letter of the 16th arrived to day and I have to thank your kindness for sending me the Barrel of Herrings. I thought whence they came being the true Yarmouth ones. ...I have been unable to taste your present for I am sorry to say I have been too unwell ever since I saw you at the Athen[a]eum when I caught cold at Lord Egremont's funeral or attending the Life Academy (got damp)....

Letter to Dawson Turner,
20 December 1837

I beg to apologize for sending for your acceptance a small Barrel of Red Herrings, but a friend of mine living at Yarmouth having sent them, I venture to warrant veritable Yarmouth's.

Letter to Charles Lock Eastlake,
23 December 1837

Advice to an aspiring artist

Dear Sir

I have truly I must say written three times and now hesitate, for did I know your son's works or as you say his *gifted merit*, yet even then I would rather advise you to think well and not be carried away by the admiration which any friendly hopes (which ardent friends to early talent) may assume. They know not the difficulties or the necessities of the culture of the *Fine Arts* generally speaking: in regard to yourself it is you alone can judge how far you are inclined to support him during perhaps a long period of expense, and particularly if you look towards tuition the more so – for it cannot ensure success (however it may facilitate the practice) and therefore it behoves you to weigh well the means in your power before you embark him in a profession which requires more care, assiduity and perseverance than any person can guarantee.

Letter to John Hammersley,
4 December 1838

Awaiting an answer

At the time of this letter, C. R. Leslie, the art agent for James Lenox, was making extravagant offers to try and acquire The Fighting 'Téméraire' *for a New York client.*

I thank you very much for your note respecting the Price of the Temeraire Picture which until I have the yea or nay of two Gentlemen who cannot make up their minds and how long I am (or ought) to wait is my present difficulty but I think of going out of Town for a few days – and will let you

know know about it (one way or other) on my return.

Letter to C. R. Leslie,
Summer 1839

In the valleys of the Rhine

Dear Hawkesworth
...I went however to Lucerne and Switzerland, little thinking or supposing such a cauldron of squabbling, political or religious, I was walking over. The rains came on early so I could not cross the Alps, twice I tried, was set back with a wet jacket and worn-out boots and after getting them heel-tapped I marched up some small valleys of the Rhine and found them more interesting than I expected.

Letter to F. H. Fawkes,
28 December 1844

Season's greetings

Mother Goose came to a rehearsal before Christmas Day, having arrived on Saturday for the knife, and could not be resisted in my drinking your good health in a glass of wine to all friends at Farnley Hall, also wishing happiness and the compts of the season to all....Ruskin has been in Switzerland with his wife this summer, and now said to be in Venice. Since the revolution shows not any damage to the works of high Art it contains, in Rome not so much as might have been expected.

Letter to F. H. Fawkes,
24 December 1849

From one of Turner's last letters

The Crystal Palace has assumed its wonted shape and size. It is situated close to the barracks at Knights Bridge, between the two roads at Kensington and not far from the Serpentine: it looks very well in front because the transept takes a centre like a dome, but sideways ribs of Glass frame work only. Towering over the Galleries like a Giant.

Letter to F. H. Fawkes,
31 January 1851

A watercolour sketch of Linlithgow Palace in Scotland, 1801.

An enigma to his contemporaries

Despite descriptions from several of his contemporaries and thirty or so portraits and sketches, Turner's personality remains something of an enigma. A lifelong bachelor, thrifty to the point of miserliness, careless about his personal appearance, a man of few words and totally devoted to his work, he remains hard to categorize. His friends and relations talked of his liveliness and apparent severity, but also of his good nature and lack of pretension.

'This little old man was Turner'

In 1847, C. H. Lear sent a caricature of Turner to his father, who collected sketches of the great painters of the Royal Academy. The picture was accompanied by this vivid verbal portrait.

Saw old Turner for the first time well. He is not at all 'Turner' as I should have expected to find him, but he is a little man dressed in a long tail coat, thread gloves, big shoes and a hat of a most miserable description made doubly melancholy by the addition of a piece of broad shabby dingy crepe encircling two thirds at least. Thus clad and with his hands behind him appeared in outward form the greatest landscape painter that ever existed and one of the greatest geniuses, perhaps the world's greatest genius, in Art. There is no evidence of unhealthy biliousness in his face; it is red and full of living blood, and although age has left its mark upon him it does not seem to have taken his energy of mind, for this lives in that observant eye and that compressed mouth, the

evidence of an acute calculating, penetrating intellect, which I may mention is seen in the whole contour of his face. He is a great little man – and all acknowledge it. I remember old Cooper told me some time ago that when any of the members of the Academy were in a mess with the effect of their pictures a single application to Turner would put all right – he never failed and his words were listened to as the law. An instance of this occurred this morning. I was standing near Herbert's picture watching him introduce an object to the left of his figure of Christ, when a little old man who stood close by me made a gruffly low sort of remark to him. Herbert turned round and with a very reverential air told him that he was going to introduce something to fill up the space to the left, at the same time showing him in his sketchbook the thing he intended. The little old man stood silent for a few seconds and then in a low but very decided tone said, 'You'll spoil your picture, you'll spoil your picture' and in a lazy sauntering movement with his hands behind him walked idly out of

the room. Herbert seemed to hesitate and put down his palette, and I turned away. In a few moments I observed the little man return, with a lazy indifferent air walk up to the picture, glance slyly at it, turn round and saunter out again. I looked at the canvas again and saw not a vestige of his proposed improvement. This little old man was Turner. They talk about his pictures being the wreck of a great mind. They are the glorious setting of a glorious sun.

Charles Hutton Lear,
diary, 3 May 1847

Anonymous visits

Turner's tenderness towards his friends was almost womanly; to be ill was to secure constant attention and solicitude from him towards the sufferer.... When the son of Charles Turner, the late eminent engraver, was dangerously ill, JMW Turner went constantly to enquire after the health of the youth and of the family; he never left his name, and this solicitude was not known to the parents until after the son's death; the servant then reported that a little short gentleman of odd manners had called every evening to know the state of the sufferer.

George Jones,
writing after Turner's death

Speaking no evil

Probably my great intimacy with him arose from his confidence (that I had his confidence is proved by his appointing me his Executor in 1831 without my knowledge) that I had no desire to know his secrets nor control his actions to suggest improvements or alter his course of life. He never interfered

with or condemned the habits of others; if he thought them incorrect, he was silent on the subject, and if any excuse or palliation could be made, his was always ready to accept, adopt or promulgate the excuse. I never heard him speak ill of anyone, and if ever he appeared morose, it was when persons were unjustly endeavouring to cajole or defraud him, which was too often the case, when his works became popular.

...During twenty-five years he indulged the pleasing hope that he should leave a testimony of his good will, and his compassion for unfortunate artists. To his intimate friends he constantly talked of the

A sketch of Turner on a Varnishing Day by John Everett Millais, 1851.

best mode of leaving property for the use of the unsuccessful; ...he did not like to call them alms houses, but had selected the denomination of 'Turner's Gift'.

<div align="right">George Jones</div>

A firm friend

He was a firm, affectionate friend to the end of his life; his feelings were seldom seen on the surface, but they were deep and enduring. No one would have imagined, under that rather rough and cold exterior, how very strong were the affections which lay hidden beneath.

<div align="right">Clara Wheeler, née Wells,
daughter of one of Turner's friends</div>

'Here I have my lesson night and day!'

Mr Turner introduced us to a small six-roomed house on the banks of the Thames, a squalid place past Lindsay Row, near Cremorne House. The house had but three windows in front but possessed a magnificent prospect both up and down the river. With this exception, the abode was miserable in every respect.... The rooms were very poorly furnished, all and everything looking as though it was the abode of a very poor man. Mr Turner pointed out, with seeming pride, to the splendid view from his single window, saying 'Here you see my study – sky and water. Are they not glorious? Here I have my lesson night and day!' The view was certainly very beautiful, but hardly of that description one would have expected the great Turner to glory in. Effect was all he required.

<div align="right">Leopold Martin,
son of the painter John Martin,
writing in 1889</div>

A 'highly intellectual' man

Introduced to-day to the man who beyond all doubt is the greatest of the age; greatest in every faculty of the imagination, in every branch of scenic knowledge; at once the painter and poet of the day, J. M. W. Turner. Everybody had described him to me as coarse, boorish, unintellectual, vulgar. This I knew to be impossible. I found in him a somewhat eccentric, keen-mannered, matter-of-fact, English-minded gentleman: good-natured evidently, bad-tempered evidently, hating humbug of all sorts, shrewd, perhaps a little selfish, highly intellectual, the powers of his mind not brought out with any delight in their manifestation, or intention of display, but flashing out occasionally in a word or a look.

<div align="right">John Ruskin,
in Praeterita,
London, 1885–89</div>

'Like a hen in a fury'

The door was opened by a hag of a woman, for whom one hardly knew what to feel most, terror or pity.... She showed us into a dining room, which had penury and meanness written on every wall and article of furniture. Then up into the gallery; a fine room – indeed, one of the best in London, but in a dilapidated state; his pictures the same. The great Rise of Carthage all mildewed and flaking off; another with all the elements in an uproar, of which I incautiously said: 'The End of the World, Mr Turner?' 'No, ma'am; Hannibal Crossing the Alps.' His Battle of Trafalgar excellent, the disposition of the figures unstudied apparently. Then he uncovered a few matchless creatures,

fresh and dewy, like pearls just set – the mere colours grateful to the eye without reference to the subjects. The *Téméraire* a grand sunset effect. The old gentleman was great fun: his splendid picture of *Walhalla* had been sent to Munich, there ridiculed as might be expected, and returned to him with £7 to pay, and sundry spots upon it: on these Turner laid his odd misshapen thumb in a pathetic way. Mr Munro suggested they would rub out, and I offered my cambric handkerchief; but the old man edged us away, and stood before his picture like a hen in a fury.

<div style="text-align: right">Elizabeth Rigby,
painter and art critic, on a visit to
Turner's house, May 1846</div>

'The first chaos of the world'

We here allude particularly to Turner, the ablest landscape-painter now living, whose pictures are however too much abstractions or aerial perspective, and representations not properly of the objects of nature as of the medium through which they are seen.... They are pictures of the elements of air, earth and water. The artist delights to go back to the first chaos of the world, or to that state of things, when the waters were separated from the dry land, and light from darkness, but as yet no living thing nor tree bearing fruit was seen on the face of the earth. All is without form and void. Someone said of his landscapes that they were *pictures of nothing and very like*.

<div style="text-align: right">William Hazlitt,
The Examiner, 1816</div>

'Astonished, enraged or delighted'

You will have heard of Mr Turner's visit to Rome; he worked literally day and night here, began eight or ten pictures and finished and exhibited three, all in about two months or a little more. More than a thousand persons went to see his works when exhibited, so you may imagine how astonished, enraged or delighted the different schools of artists were, at seeing things with methods so new, so daring, and excellences so unequivocal. The angry critics have, I believe, talked most, and it is possible you may hear of *general* severity of judgment, but many did justice, and many more were fain to admire what they confessed they dared not imitate.

<div style="text-align: right">Charles Eastlake,
letter to a friend,
February 1828</div>

A watercolour illustration of Loch Achray, *c*. 1832, for Sir Walter Scott's *The Lady of the Lake*.

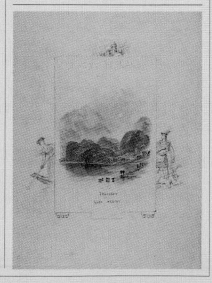

Ruskin on Turner

John Ruskin, child prodigy and scholar, devoted thousands of pages of writings to Turner. In the five volumes of Modern Painters, *published between 1843 and 1860, as well as other works, he described and analysed Turner's work with a passion equalled only by his enormous attention to detail. While praising Turner to the skies, he also had no hesitation in criticizing and rejecting some of the great painters of the past. The pinpoint accuracy of his comments is remarkable.*

'Turner's translation of colours'

It is true that there are, here and there, in the Academy pictures, passages in which Turner has translated the unattainable intensity of one tone of colour, into the attainable pitch of a higher one: the golden green, for instance, of intense sunshine on verdure, into pure yellow, because he knows it to be impossible, with any mixture of blue whatsoever, to give faithfully its relative intensity of light, and Turner always will have his light and shade right, whatever it costs him in colour. But he does this in rare cases, and even then over very small spaces; and I should be obliged to his critics if they would go out to some warm, mossy green bank in full summer sunshine, and try to reach its tone; and when they find, as find they will, Indian yellow and chrome look dark beside it, let them tell me candidly which is nearest truth, the gold of Turner, or the mourning and murky olive browns and verdigris greens in which Claude, with the industry and intelligence of a Sevres china painter, drags the laborious bramble leaves over his childish foreground.

'The basis of grey, under all his vivid hues'

Throughout the works of Turner, the same truthful principle of delicate and subdued colour is carried out with a care and labour of which it is difficult to form a conception. He gives a dash of pure white for his highest light; but all the other whites of his picture are pearled down with grey or gold. He gives a fold of pure crimson to the drapery of his nearest figure, but all his other crimsons will be deepened with black, or warmed with yellow. In one deep reflection of his distant sea, we catch a trace of the purest blue, but all the rest is palpitating with a varied and delicate gradation of harmonized tint, which indeed looks vivid blue as a mass, but is only so by opposition. It is the most difficult, the most rare thing, to find in his works a definite space, however small, of unconnected colour;

that is, either of a blue which has nothing to connect it with the warmth, or of a warm colour, which has nothing to connect it with the greys of the whole; and the result is, that there is a general system and under-current of grey pervading the whole of his colour, out of which his highest lights, and those local touches of pure colour, which are, as I said before, the key-notes of the pictures, flash with peculiar brilliancy and intensity in which he stands alone.

'His dislike of purple, and fondness for the opposition of yellow and black. The principles of nature in this respect.'

What I am next about to say with respect to Turner's colour, I should wish to be perceived with caution, as it admits of dispute. I think that the first approach to viciousness of colour in any master is commonly indicated chiefly by a prevalence of purple, and an absence of yellow. I think nature mixes yellow with almost every one of her hues, never, or very rarely, using red without it, but frequently using yellow with scarcely any red; and I believe it will be in consequence found that her favourite opposition, that which generally characterizes and gives tone to her colour, is yellow and black, passing, as it retires, into white and blue. It is beyond dispute that the great fundamental opposition of Rubens is yellow and black; and that on this, concentrated in one part of the picture, and modified in various greys throughout, chiefly depend the tones of all his finest works. And in Titian, though there is a far greater tendency to purple than in Rubens, I believe no red is ever mixed with the pure blue, or glazed over it, which has not in it a modifying quantity of yellow.

At all events, I am nearly certain that whatever rich and pure purples are introduced locally, by the great colourists, nothing is so destructive of all fine colour as the slightest tendency to purple in general tone; and I am equally certain that Turner is distinguished from all the vicious colourists of the present day, by the foundation of all his tones being black, yellow, and the intermediate greys, while the tendency of our common glare-seekers is invariably to pure, cold, impossible purples. So fond indeed is Turner of black and yellow, that he has given us more than one composition, both drawings and paintings, based on these two colours alone, of which the magnificent Quilleboeuf, which I consider one of the most perfect pieces of simple colour existing, is a most striking example; and I think that where, in some of the late Venices, there has been something like a marked appearance of purple tones, even though exquisitely corrected by vivid orange and warm green in the foreground, the general colour has not been so perfect or truthful: my own feelings would always guide me rather to the warm greys of such pictures as the Snowstorm, or the glowing scarlet and gold of the Napoleon and Slave-ship. But I do not insist at present on this part of the subject, as being perhaps more proper for future examination, when we are considering the ideal of colour.

'The intense and constant study of clouds by Turner'

There is but one master whose works we can think of while we read this; one alone has taken notice of the neglected upper sky; it is his peculiar and favourite field; he has watched its

every modification, and given its every phase and feature; at all hours, in all seasons, he has followed its passions and its changes, and has brought down and laid open to the world another apocalypse of heaven.

There is scarcely a painting of Turner's, in which serenity of sky and intensity of light are aimed at together, in which these clouds are not used, although there are not two cases in which they are used altogether alike. Sometimes they are crowded together in masses of mingling light, as in the Shylock; every part and atom sympathising in that continuous expression of slow movement which Shelley has so beautifully touched: 'Underneath the young grey dawn / A multitude of dense, white fleecy clouds, / Were wandering in thick flocks along the mountains, / Shepherded by the slow, unwilling wind.'

At other times they are blended with the sky itself, felt only here and there by a ray of light calling them into existence out of its misty shade, as in the Mercury and Argus; sometimes, where great repose is to be given, they appear in a few detached, equal, rounded flakes, which seem to hang motionless, each like the shadow of the other, in the deep blue of the zenith, as in the Acro-Corinth; sometimes they are scattered in fiery flying fragments, each burning with separate energy, as in the Temeraire; sometimes woven together with fine threads of intermediate darkness, melting into the blue, as in the Napoleon. But in all cases the exquisite manipulation of the master gives to each atom of the multitude its own character and expression. Though they be countless as leaves, each has its portion of light, its shadow, its reflex, its peculiar and separating form.

'Turner's Noblest Work: the painting of the deep open sea in *The Slave Ship*'

But I think the noblest sea that Turner has ever painted, and, if so, the noblest certainly ever painted by man, is that of the Slave Ship, the chief Academy picture of the Exhibition of 1840. It is a sunset on the Atlantic, after prolonged storm; but the storm is partially lulled, and the torn and streaming rain-clouds are moving in scarlet lines to lose themselves in the hollow of the night. The whole surface of sea included in the picture is divided into two ridges of enormous swell, not high, nor local, but a low broad heaving of the whole ocean, like the lifting of its bosom by deep-drawn breath after the torture of the storm. Between these two ridges the fire of the sunset falls along the trough of the sea, dyeing it with an awful but glorious light, the intense and lurid splendour which burns like gold, and bathes like blood. Along this fiery path and valley, the tossing waves by which the swell of the sea is restlessly divided, lift themselves in dark, indefinite, fantastic forms, each casting a faint and ghastly shadow behind it along the illuminated foam. They do not rise everywhere, but three or four together in wild groups, fitfully and furiously, as the under strength of the swell compels or permits them; leaving between them treacherous spaces of level and whirling water, now lighted with green and lamp-like fire, now flashing back the gold of the declining sun, now fearfully dyed from above with the undistinguishable images of the burning clouds, which fall upon them in flakes of crimson and scarlet, and give to the reckless waves the added motion of their own fiery flying. Purple and blue, the lurid shadows of the

hollow breakers are cast upon the mist of the night, which gathers cold and low, advancing like the shadow of death upon the guilty ship as it labours amidst the lightning of the sea, its thin masts written upon the sky in lines of blood, girded with condemnation in that fearful hue which signs the sky with horror, and mixes its flaming flood with the sunlight, and, cast far along the desolate heave of the sepulchral waves, incarnadines the multitudinous sea.

'His former rank and progress'

There has been marked and constant progress in his mind; he has not, like some few artists, been without childhood; his course of study has been evidently as it has been swiftly progressive, and in different stages of the struggle, sometimes one order of truth, sometimes another, has been aimed at or omitted. But from the beginning to the present height of his career, he has never sacrificed a greater truth to a less. As he advanced, the previous knowledge or attainment was absorbed in what succeeded, or abandoned only if incompatible, and never abandoned without a gain; and his present works present the sum and perfection of his accumulated knowledge, delivered with the impatience and passion of one who feels too much, and knows too much, and has too little time to say it in, to pause for expression, or ponder over his syllables. There is in them the obscurity, but the truth, of prophecy; the instinctive and burning language, which would express less if it uttered more, which is indistinct only by its fulness, and dark with its abundant meaning. He feels now, with long-trained vividness and keenness of sense, too bitterly the impotence of the hand, and the vainness of the colour to catch one shadow or one image of the glory which God has revealed to him.

John Ruskin,
Modern Painters, vol. 1,
London, 1843

A page from an exhibition catalogue, with two sketches of boats by Turner, *c.* 1823.

Views from abroad

After Turner's death, his work continued to be a subject for debate among artists and critics both nationally and internationally. In London, the gallery devoted to his work became a place where painters came to study, admire and learn from the master's teachings. The paintings of the Impressionist movement were often compared to Turner's, but the Impressionists themselves did not always welcome such a close identification.

'Marked by exaggeration'

Lawrence, Turner, Reynolds, in general all the great English artists, are marked by exaggeration, particularly in effect, which prevents them from being classed among the great masters. These extravagant effects, these dark skies, these contrasts of shadow and light, to which they have been led by their own cloudy and changeable skies, but which they have exaggerated beyond all bounds, speak more of their faults than of their qualities: faults they have followed through fashion and through personal bias. They have produced some magnificent paintings, but these will never possess the eternal freshness of true masterpieces, free, I would dare say, from strain and excess.

Eugène Delacroix,
Journal, 8 February 1860

'Turner's Impressionism'

When, after a trip to Italy, he finally opened his eyes to the truth, he rid his palette of dull tar-like colours, he opened his window wide and noticed that the light that bathes objects outside is not the same as that which falls from a studio lamp; when he joyfully began to paint, in gleaming colours and shimmering, pearly shades, the sparkling of the sea as it is kissed by the sun, the morning rays in the pale clear sky, and the jewel-like glitter amid the opaline mists that is Venice: it was at that moment that Turner was declared to be mad and the world turned its back on him.

If the term Impressionist had been invented then, it would have been thrown at him like an insult, and he would have dragged the word behind his name as the years went by. But neither the word nor the cheap newspapers whose job it is to attach such noisy shackles existed yet.

Now that the epithet has become a glorious thing, it may be bestowed upon the name of Joseph Mallord William Turner. What strange destinies words may have! Yesterday an insult, today a rallying cry, tomorrow a symbol of victory.

....Turner's impressionism cannot be denied. From the day that he deliberately broke with the ancient

formulae, he made the phenomena of light the constant and passionate study of his life. He took the spectrum of sunlight apart, and tried to express its magical effects on canvas through combinations of the simple shades of which it is composed. The gauzy, gold-flecked mists that dawn stretches over the waters, the blazing fires lit in the sky by the setting sun, the more subtle shifts in tone that are created by rain, fog or snowstorms, the mist that rises off the sea in sunlight: he obstinately pursued the precise way to convey them all, and often succeeded in capturing them by happy accident, in harmonious dabs of paint.

The process lately used by the French impressionists, Claude Monet and his school, the juxtaposition of simple tones that produces, at a distance, vibrations of an amazing intensity, can be found in embryonic form in Turner's work. In most of the pictures that date from his third period, his definitive period, pure purple, pure ultramarine, pure cadmium are all audaciously applied to the canvas, even to the backgrounds. The most striking example is found in the painting catalogued by the National Gallery as *Ulysses Deriding Polyphemus*, which shows, amid a fantastic landscape of rocks filled with grottoes and caves standing in the blue waters of the sea, the Greek hero standing on the prow of his ship, defying the giant who can be vaguely seen beyond the mountains, lost among the clouds that are torn apart like veils by the rays of the rising sun.

It is easy to be convinced, by examining the many unfinished studies in the collection, that such was the artist's usual procedure, often hidden, it is true, unlike the Impressionists of today, under the superimposed layers of varnish.

Approach to Venice, Peace – Burial at Sea, The Sun of Venice Going to Sea, Apollo and Python, The Bay of Baiae, Queen Mab's Cave, The Fighting 'Temeraire': this whole astonishing series of compositions, in which the fantastic is combined with truth of impression – and even the half-allegorical, half-realistic canvas, which the painter named (I quote from memory, so the title may not be correct) *Rain, Sun, Steam*, which shows a train from the Great Western Railway speeding over a viaduct – all of these works, shall we say, derive from the same principles and involve similar procedures.

What makes Turner original is that his imagination and observation are constantly at war within his artist's soul; from this duality is born a mixed body of work, that does not fulfil the demands of either the pure idealists or of the lovers of realism, but which is nonetheless of great interest and signifies a wonderfully strong character. One might imagine Turner as a kind of tree whose roots feed from both the fertile ground of reality and from the field of legend. Fed on both of these sources, tormented by these contradictory springs, he blossoms with multicoloured leaves, spreading his branches over the two soils over which he casts a shadow, without it being possible to tell in which of them he is more strongly rooted.

Such plants as these, like all hybrid creations, cannot breed. Turner produced no school. His individuality ...was too utterly singular. He remains an isolated phenomenon within the history of art, and yet exerts an unusual attraction to all those around him.

Emile Verhaeren,
'L'impressioniste Turner',
L'Art Moderne, Brussels,
20 September 1885

'Good Lord!'

An afternoon spent before the English paintings of [industrialist Camille] Groult. Among these canvases is a Turner [*Landscape with Distant River and Bay*]: an ethereal blueish lake, with hazy contours, a distant lake under an electric glow of sunlight, beyond a wild landscape. Good Lord! It makes you scornful of the innovation of some of our innovative painters today.

The Goncourts,
Journal, 18 January 1890

'This Turner is molten gold'

I was working when Groult turned up at my house and, despite my resistance, insisted on taking me to see his Turner.

Well, I have no regrets about that lost half-day, because that painting is one of the ten paintings that have given me the greatest pleasure; this Turner is molten gold, with a swirling of purple within that gold. A painting before which the painter Moreau fell down in ecstasy, though he did not even known Turner by name. Ah, the Salute, the Ducal Palace, the sea, the sky with the rosy transparency of amalgatolite; all of this looking like an apotheosis of precious stones and of colour in droplets, in drips and in dots, like those you see decorating pottery from the Far East. To me, it seemed a picture painted by a Rembrandt born in India.

What is more, the beauty of this painting is not made from anything that is preached in any theoretical book; it is created from violent emotion, full contact, excess of attention to detail, the kind of attention to detail, I repeat, that marks the work of the great painters who bear the names of Rembrandt, Rubens, Velásquez and Tintoretto.

The Goncourts,
Journal, 12 August 1891

The study of shadows

In this letter to his son, Camille Pissarro is responding to an article by the English painter Wynford Dewhurst, which claimed that Impressionism was primarily based on English artists, with Turner major amongst these. Pissarro tries to explain that Impressionism owed more to the art of the 18th century in general than to Turner in particular.

This Mr Dewhurst understands nothing about the Impressionist movement. He sees nothing but a process of execution and he gets all the names mixed up.... He also says that before going to London [Monet and I] had no idea about light; however, we have studies that prove the opposite. He leaves out the influence of Claude Lorrain, Corot, the whole 18th century, especially Chardin. But what he firmly believes is that Turner and Constable confirmed to us that these painters did not understand the study of shadows, which, in Turner's work, is the very essence of the effect, a hole.

As far as the division of colours is concerned, Turner confirmed to us its worth as a procedure, but not as a truth or part of nature. Besides, the 18th century was our tradition. I think that Turner too looked at Claude Lorrain, and I also think that there is a Turner *Sunset* placed alongside a Claude. How typical.... What do you think? He has some nerve, this Mr Dewhurst.

Letter from Camille Pissarro
to his son, 8 May 1902

The Parting of Hero and Leander

In the twentieth and twenty-first centuries, Turner and his work have continued to provoke critical discussion and controversy. Here, Andrew Wilton examines The Parting of Hero and Leander *(illustrated on page 150), a lesser-known painting whose merits have often been dismissed in the face of changing public tastes.*

The popular late twentieth-century perception of Turner as a forerunner of Impressionism and abstraction presupposes that he pioneered a new informality, a new immediacy in painting; that he was, first and foremost, an instinctive, expressionist artist. As recently as last year an American critic could write of 'his powerful style, his way with paint, his extraordinary use of color', and argue that 'these gifts and accomplishments, and these alone, are the reasons we heed and honor Turner.' Ruskin himself is invoked to support such an interpretation: he 'made a great point of Turner's "Truth to nature"', and this is seen as a further indication of the artist's 'modernity', as if it were to be equated with Impressionist spontaneity. The *Snow Storm – Steamboat off a Harbour's Mouth* of 1842 is called as witness to the 'abstract' results of Turner's first-hand experience of the elements.

It may be an inevitable corollary of the apparent 'relevance' of the *Snow Storm* and its undoubted popularity in recent decades that pictures like *Hero and Leander* – also late; it was exhibited in 1837 – should have been noticeably less *en vogue*. Even an irresistibly shimmering late Turnerian vision of classical Italy, *Cicero at his Villa*, which

one would have thought embodied nearly all the traditionally admired qualities of a 'great' Turner, seems to be sealed from us now (if its failure to attract a bid at auction last summer is anything to go by) simply and solely because it deals, in extensive and delighted detail, with the minutiae of life in the ancient world. There is something Reynoldsian about the doctrinaire modern segregation of 'acceptable' from 'unacceptable' subject-matter. *Hero and Leander*, presumably, is in the same category as *Cicero*; though it has no Italian haze, no breathtaking panorama to entice the eye, and so is, no doubt, still duller. It has always been considered one of the least interesting of the works in the Turner representation at the National Gallery, and has now, temporarily, been transferred to the walls of the Clore Gallery, where, in its original acanthus-leaf frame, it hangs in murky splendour among the bright Mediterranean subjects around it.

These, too, are far from being obviously relevant to the modern world. They are idyllic landscapes or heroic cityscapes, evocations of a remote and achingly beautiful, but purely imaginary, past. That past mattered greatly to Turner and his contemporaries, and his ability to think himself into it, to

recreate it for his own time in immense detail, was a faculty they valued, as they valued it in a very different master (whom Turner revered), Poussin.

We too can derive pleasure from these works, because they demonstrate Turner's mastery of light, his 'way with paint, his extraordinary use of color'. In *Hero and Leander*, though, the light is dimmed, almost quenched; we are plunged into a twilight pregnant with foreboding. Here again Turner's admiration for Poussin is apparent: his description of the Staedel *Pyramus and Thisbe* (then in a London collection) comes to mind. Among his lecture notes he wrote, rather helter-skelter:

Whether we look upon the dark sky illumined at the right hand corner by lightning rushing behind the bending trees and at last awfully gleaming its dying efforts upon some antique buildings on the left; while all beneath amid scattered foliage and broken tombs lied the dying figure of Pyramus, and [in] the depth of darkness all is lost but returning Thisbe.

To argue, in the light of such an analysis, that Turner's art can be understood by divorcing his light and colour from its narrative or 'historical' content is patently absurd. To say that *Hero and Leander* lacks the characteristically Turnerian light and colour which could make it interesting for us today would be logically the next step, but is absurd too. Yet many people would undoubtedly find it easier to admire the picture if it were reduced to, say, its central 'light motif' – the wan glimmer of dawn on the horizon, contrasted with the thin moon above in its wrack of clouds. Such an 'abstraction' does exist, in the wonderful study known as *The Evening Star* which has

also hung for many years at Trafalgar Square, and has, significantly, come to enjoy much greater popularity than *Hero and Leander*.

There, the same colours are employed to produce a similar effect of light: a tender mauve-blue is shot through by evanescent streaks of rose-pink and gold; there is the same melting, changing flood of delicate light in both, the comparable reflection of a planet on a wet beach, a like horizon dark with mystery. But in *The Evening Star* these elements are enveloped in a hushed tranquillity; the shrimper and his jumping dog are the necessary witnesses to the ineffable calm, though most people would perhaps deny that their presence is important.

The mood could not be more different in *Hero and Leander*. The mystery of dawn is presented as fraught with tragedy; the possibilities hidden in futurity are manifest in a violent clash of elements, which spin around that central glow as if threatening its survival. The canvas is much larger than that of the study; it is, indeed, a full-sized stage on which a vast drama is being acted out, in best Poussinesque or Wilsonian tradition, by human protagonists and natural phenomena alike. But this whirlpool is not the customary homogeneous vortex of air and light that we are used to finding in Turner's late paintings. On the contrary, the distant view of sun and moon dividing the sky between them serves also to divide the canvas into two quite distinct halves. To the left is a perspective of classical buildings of a grandeur that even Turner rarely matched. Our eyes are drawn smoothly across an inlaid pavement – there is a classical subject by Turner worked into it in mosaic – and down steps to a lower platform where a

fountain plays; then up again in a grand and irresistible swing (duplicated two years later in the garden of Cicero's villa) to where a grove of trees is planted, and among them a small circular temple. Behind this rears a watchtower like that which used to stand on the Acropolis at Athens, and a screen borrowed from the Arch of Hadrian as published by Athenian Stuart. More towers and temples soar above these into a pale mist of low cloud which hovers out over the water. All is architecture, geometry, order. The classical world offers its assurances of reason and harmony. But below the high town a fragile bridge leads out onto rocks surmounted by a round tower of the sort Turner saw in northern Europe along the Rhine or the Moselle: it nods in grim and gothic silence across the black water to a companion tower on a rock that is almost invisible amid the confusion that reigns on the opposite side of the composition. Here a jagged headland leans out into the sea and convoluted rocks allow half-glimpses of dark recesses where unearthly figures glow with the phosphorescence of the waves. The breakers that surge up the steep cliff disperse splashing into crowds of leaping naiads and sea-sprites. The untameable forces of nature hold sway. We stand on the apparently safe and solid structures of civilization and are suddenly granted an insight into the terrors that lie immediately beyond our quotidian experience. And ironically it is the youthful god of love and his companion Hymen who illuminate the scene as we contemplate it. They stand, in attitudes of intense concern, in the foreground of the rising terrace, almost at the centre of the design; but in the true middle of the picture, faintly visible and already, it seems, absorbed into the elements, the

lovers stand clinging together as they make their adieus, as if they knew only too well the miserable fate that awaits them. The revelation of what life has in store is almost unbearable: Pandora's Box yields its last secret, and, like Cupid, we turn away our eyes, unable to watch any longer.

It is no modest, domestic drama, no freshly observed scene of everyday English life. It is overblown, artificial – Turner was frequently both; it is like grand opera – Gluck, Weber and Verdi, even the Wagner of *The Flying Dutchman* – all rolled into one. No one (except perhaps certain 'progressive' directors) asks that those composers should present their ideas in 'modern' dress. We accept their masterpieces as they made them, and try to understand then better as they were written. We should not wish to 'rewrite' Turner on the ground that he meant his historical subjects only as a sop to a limited contemporary taste.

Some years ago a production of Mozart's *Idomeneo* at Glyndebourne made use of subjects from Turner paintings for its sets. The designer felt that the classical story of a monster sent by Neptune from the sea to devour the people of Crete chimed well with some of Turner's preoccupations. One of his scenes was based on the Antique perspective in *Hero and Leander*. It was in its element.

Andrew Wilton
first published in *Apollo*,
January 1989, pp. 46–47.
Reprinted with the
author's permission.

FURTHER READING

CATALOGUES RAISONNÉS

Martin Butlin and Evelyn Joll, *The Paintings of J.M.W. Turner*, 2 vols, New Haven, 1984

Alexander Joseph Finberg, *The National Gallery: A Complete Inventory of the Drawings of the Turner Bequest*, 2 vols, London, 1909

Luke Herrmann, *Turner Prints: The Engraved Work of J. M. W. Turner*, London, 1990

MONOGRAPHS

Alexander Joseph Finberg, *The Life of J. M. W. Turner, R.A.*, Oxford, 2nd ed., 1961

John Gage, ed., *The Collected Correspondence of J. M. W. Turner*, Oxford, 1980

John Gage, *Colour in Turner: Poetry and Truth*, New York, 1969

John Gage, *J. M. W. Turner, 'A Wonderful Range of Mind'*, New Haven, 1987

Lawrence Gowing, *Turner: Imagination and Reality*, New York, 1966

Evelyn Joll, Martin Butlin and Luke Herrmann, *The Oxford Companion to J. M. W. Turner*, Oxford, 2001

Michael Kitson, *J. M. W. Turner*, New York, 1964

Jack Lindsay, *J. M. W. Turner: His Life and Work, a Critical Biography*, New York, 1966

Graham Reynolds, *Turner*, London, 1969

John Ruskin, *Modern Painters*, 5 vols, London, 1873

Walter Thornbury, *The Life of J. M. W. Turner, R.A.*, 2 vols, London, 1862

Andrew Wilton, *The Life and Work of J. M. W. Turner*, London, 1979

Andrew Wilton, *Turner in his Time*, London and New York, 1987

EXHIBITION CATALOGUES

Martin Butlin, *Turner, 1775–1851*, London, 1975

John Gage et al., *J. M. W. Turner*, Paris, 1983

Michael Lloyd, *Turner*, Canberra, 1996

Cecilia Powell, *Turner in Germany*, London, 1995

Ian Warrell, *Through Switzerland with Turner*, London, 1995

Ian Warrell, *Turner on the Loire*, London, 1997

Ian Warrell, *Turner on the Seine*, London, 1999

Ian Warrell, *Turner and Venice*, London, 2003

Andrew Wilton, *Turner and the Sublime*, Toronto, New Haven, London, 1980

INTERNET

The Tate website http://www.tate.org.uk contains an extensive catalogue of Turner's paintings and drawings: over 40,000 works from public and private collections.

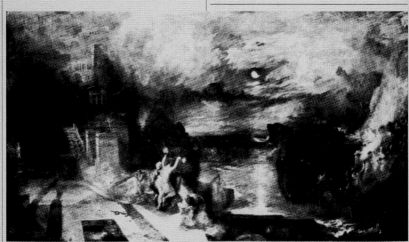

Below, *The Parting of Hero and Leander – from the Greek of Musaeus*, 1837.

LIST OF ILLUSTRATIONS

The titles of paintings by Turner are followed in parentheses by their number in the catalogue raisonné compiled by Martin Butlin and Evelyn Joll (BJ); the major watercolours are followed by their number in the catalogue in The Life and Work of J. M. W. Turner *by Andrew Wilton (W); other works are followed by their Tate inventory number. The addition of (RA) or (BI) following a date indicates the year in which a work was shown at the Royal Academy or the British Institution.*

Abbreviations used: *a* above; *b* below; *c* centre.

COVER

Front *Slavers Throwing Overboard the Dead and Dying – Typhon Coming On* or *The Slave Ship* (detail, BJ385), 1840 (RA), oil on canvas, 91 x 138 cm. Henry Lillie Pierce Fund, Museum of Fine Arts, Boston.
Spine *Helvoetsluys – The City of Utrecht, 64, Going to Sea* (detail, BJ345), 1832 (RA), oil on canvas, 91.4 x 122 cm. Tokyo Fuji Art Museum, Tokyo.
Back John Ruskin, *Portrait of J. M. W. Turner RA*, *c.* 1840, cut-out silhouette on black paper and watercolour, 26.5 x 18.5 cm. RA, London.

OPENING

1 *Venice: San Giorgio Maggiore – Early Morning* (detail, D15254), from the *Como and Venice* sketchbook, 1819, watercolour, 22 x 28.7 cm. Tate, London.
2–3 *Venice: The Upper End of the Grand Canal, with San Simeone Piccolo; Dusk* (D32124), from the *Venice* sketchbook, 1840, watercolour, gouache, pencil and ink, 21.9 x 32 cm. Tate, London.
4–5 *Venice: Looking down the Grand Canal to Palazzo Corner della Cà Grande and Santa Maria della Salute* (D32122), from the *Venice* sketchbook, 1840, pencil and watercolour, 22.1 x 32.5 cm. Tate, London.
6–7 *Venice: Sunset over Santa Maria della Salute and the Dogana* (D32130), from the *Venice* sketchbook, *c.* 1840, watercolour, 22.1 x 32.1 cm. Tate, London.
8–9 *Venice at Sunrise from the Hotel Europa, with the Campanile of San Marco* (D35949), 1840, watercolour, 19.8 x 28 cm. Tate, London.
11 S. W. Parrott, *Turner on Varnishing Day*, *c.* 1846, oil on canvas. Ruskin Collection, Sheffield City Art Gallery, Sheffield.

CHAPTER 1

12 *Self-portrait*, *c.* 1799, oil on canvas, 74.3 x 58.4 cm. Tate, London.

13 The awarding of a Royal Academy diploma to J. M. W. Turner, *Royal Academy Council Minutes* (vol. III), 31 December 1799. Royal Academy of Arts (RA), London.
14 *The Head of a Woman Wearing a Ruched Cap, Looking Down* (D00310), from the *Marford Mill* sketchbook, *c.* 1793, pencil, 15.1 x 10.1 cm. Tate, London.
14–15 Registry of baptisms at St Paul's Church, Covent Garden for 14 May 1775. City of Westminster City Archives Centre, London.
15 John Collet, *Covent Garden Piazza and Market*, *c.* 1775, oil on canvas. Museum of London, London.
16a *Self-portrait* (W11), 1791, watercolour, 9.5 x 7 cm. National Portrait Gallery (NPG), London.
16c *Study of the Belvedere Antinous* (D00064), *c.* 1793, chalk and gouache, 40.3 x 21.5 cm. Tate, London.
16b *A Street in Margate, Looking Down to the Harbour* (W2), 1784 (?), pen, black ink and watercolour, 27 x 40.7 cm. Private collection.
17 Edward Francis Burney, *The Antique School at Old Somerset House*, *c.* 1779, pen and ink with watercolour wash, 33.7 x 48.9 cm. RA, London.
18 *View up the Avon from Cook's Folly* (D00107), from *Bristol and Malmesbury* sketchbook, 1791, watercolour, 18.2 x 26.3 cm. Tate, London.
18–19 *The Archbishop's Palace, Lambeth* (W10), 1790 (RA), watercolour, 26.7 x 38.1 cm. Gift in memory of Dr and Mrs Hugo O. Pantzer, Indianapolis Museum of Art, Indiana.
19 Title page from the catalogue of the Royal Academy of Arts annual exhibition, 1790. RA, London.
20a Thomas Monro, *J. M. W. Turner at his Drawing Table*, *c.* 1795, pencil. Bequest of Kurt F. Pantzer, Indianapolis Museum of Art, Indiana.
20b Box of watercolours manufactured by T. Reeves & Son between 1766 and 1783. Private collection.
21 J. M. W. Turner and Thomas Girtin, *Florence from the Cascine* (D36525), *c.* 1795–97, pencil and watercolour, 28.2 x 20.9 cm. Tate, London.
22–23 Alexander Cozens, drawings from *A New Method of Assisting the Invention in Drawing Original Compositions of Landscape*, aquatint and etching, J. Dixwell, London, 1785. Private collection.
22b Title page from *Observations Relative Chiefly to Picturesque Beauty, Made in the Year 1772, on Several Parts of England*, by William Gilpin, R. Blamire, London, 1786. Bibliothèque Nationale, Paris.
24 *St Erasmus and Bishop Islip's Chapels, Westminster Abbey* (W138), 1796 (RA), pencil and watercolour, 54.6 x 39.8 cm. British Museum, London.
25a *A River with Trees and Buildings against a Sunset*

CHAPTER 2

54 *Dürer's Perspective Fenestre* (D07360), from the *Perspective* sketchbook, *c.* 1809, pen and ink, 8.8 x 11.5 cm. Tate, London.

54–55 *Reflections in a Single Polished Metal Globe and in a Pair of Polished Metal Globes* (D17147), *c.* 1810, oil and pencil on paper, 64 x 96.8 cm. Tate, London.

55 Thomas Cooley, *Joseph Mallord William Turner; Henry Fuseli*, *c.* 1812, pencil. NPG, London.

56 John Linnell, *Portrait Study of J.M.W. Turner's Father, with a Sketch of Turner's Eyes, made during a Lecture*, *c.* 1812, pencil. Tate, London.

56–57 George Jones, *Turner's Gallery; the Artist Showing his Work*, *c.* 1852, oil on board. Ashmolean Museum, Oxford.

57 Autograph letter by J. M. W. Turner announcing an exhibition at his gallery, 9 May–20 June 1814. British Library, London.

58a Title page from *A Complete Edition of the Poets of Great Britain*, vol. IX, by Robert Anderson, John & Arthur Arch, London, 1795 (Turner's own copy). Private collection.

58b *The Garreteer's Petition* (BJ100), 1809 (RA), oil on wood, 55.2 x 79.1 cm. Tate, London.

59 Entry for *The Garreteer's Petition* in the catalogue for the Royal Academy exhibition, 1809. RA, London.

CHAPTER 3

60 *The Grand Canal, Venice* (BJ368), 1837 (RA), oil on canvas, 148 x 110.5 cm. Courtesy of the Huntington Library, Art Collections And Botanical Gardens, San Marino, California.

61 Title page from Turner's annotated copy of *Manuel du voyageur, or The Traveller's Pocket Companion* by Madame de Genlis, Samuel Leigh, London, 1829. Private collection.

62 *Messieurs les voyageurs on their Return from Italy (par la diligence) in a Snow Drift upon Mount Tarrar – 22nd of January, 1829* (W405), 1829 (RA), watercolour and gouache, 54.5 x 74.7 cm. Trustees of the British Museum (R.W. Lloyd Bequest), London.

63 Travelling watercolour set made by J. M. W. Turner from an old almanac and used from 1814. Private collection (on loan to the Tate, London).

64a *Tantallon Castle* (W1067), 1821, watercolour and gouache, 17.4 x 25.7 cm. Manchester City Galleries, Manchester.

64b George Cooke, *Edinburgh Castle*, engraving after J. M. W. Turner, title page of *Provincial Antiquities and Picturesque Scenery of Scotland* by Sir Walter Scott, 1826. Tate, London.

65 William Bernard Cooke, *Tantallon Castle*, engraving after J. M. W. Turner, 1834. Tate, London.

66 John Thomas Smith, *J. M. W. Turner in the Print Room of the British Museum*, *c.* 1829, watercolour, 22.2 x 18.2 cm. British Museum, London.

67a Francis Holl, *Portrait of John Ruskin*, engraving after George Richmond, 19th century. Private collection.

67b Title page of the first edition of John Ruskin, *Modern Painters*, Smith, Elder & Co., London, 1843. Private collection.

68 *The Devil's Bridge, near Andermatt, Pass of St Gothard* (D04626), 1802, pencil, watercolour and gouache, 47.1 x 31.8 cm. Tate, London.

69a *The Fall of an Avalanche in the Grisons* or *Cottage Destroyed by an Avalanche* (BJ109), 1810 (Turner Gallery), oil on canvas, 90.2 x 120 cm. Tate, London.

69b Philippe Jacques de Loutherbourg, *An Avalanche in the Alps*, 1803, oil on canvas, 109.9 x 160 cm. Tate Gallery, London.

70 *Snow Storm: Hannibal and his Army Crossing the Alps* (BJ126), 1812 (RA), oil on canvas, 146 x 237.5 cm. Tate, London.

71 *Snow Storm: Hannibal and his Army Crossing the Alps* (detail), as above.

72–73 *The Red Rigi* (W1525), 1842, watercolour, 30.5 x 45.8 cm. National Gallery of Victoria, Melbourne.

74a Inscriptions by J. M. W. Turner (D13859), in the *Route to Rome* sketchbook, 1819, pencil and ink, 8.7 x 11.7 cm. Tate, London.

74b *The Colosseum* (D16398), in the *Small Roman Colour Studies* sketchbook, 1819, pencil and watercolour, 13.3 x 25.5 cm. Tate, London.

75 Twelve copies from John Warwick Smith's *Select Views in Italy* (D13966), in the *Italian Guide Book* sketchbook, 1819, pencil, 15.5 x 9.9 cm. Tate, London.

76 *Rome, from the Vatican. Raffaelle, accompanied by La Fornarina, preparing his pictures for the Decoration of the Loggia* (BJ228), 1820 (RA), oil on canvas, 177.2 x 335.3 cm. Tate, London.

76–77 *Childe Harold's Pilgrimage – Italy* (BJ342), 1832 (RA), oil on canvas, 142.2 x 248.3 cm. Tate, London.

78–79 *The Bacino looking East, with Sketches of the Sky* (D14527), in the *Venice to Ancona* sketchbook, 1819, pencil, 11.1 x 18.4 cm. Tate, London.

79 Cover of the *Milan to Venice* sketchbook (D40890), 1819, 11.2 x 18.5 cm. Tate, London.

80a Anonymous, *View of Venice*, *c.* 1860, photograph. Château-Musée, Nemours.

80b *The Campanile of San Marco, with the Pilastri Acritani, from the Porta della Carta* (D32204), *c.* 1840, gouache, pencil and watercolour, 28.2 x 19.1 cm. Tate, London.

81 *Turner's Bedroom in the Palazzo Giustinian (the Hotel Europa), Venice* (D32219), *c.* 1840, watercolour and gouache, 23 x 30.2 cm. Tate, London.

82–83 *The Ducal Palace, Dogano, with part of San*

CHAPTER 4

CHAPTER 5

DOCUMENTS

INDEX

PICTURE CREDITS

Allen Memorial Art Museum, Ohio: 82–83. All Rights Reserved: 22–23. Ashmolean Museum, Oxford: 88b. Bibliothèque du Musée du Louvre, Paris: 88–89, 89b. Bibliothèque Nationale de France: 22b. Bridgeman Art Library: front cover, spine, 11, 15b, 18–19, 20a, 24, 27, 40, 44a, 45, 48–49, 50–51, 56–57, 62, 67a, 72–73, 92, 94b, 96, 100, 102, 106–107, 112, 119a, 131, 135, 137, 139, 143. British Library, London: 57, 94–95, 107b, 129. British Museum, London: 66, 103a. Christie's Images / Corbis: 121. City of Westminster City Archives Centre, London: 14–15. Cleveland Museum of Art, Ohio: 98–99. Huntington Library, San Marino, California: 60. Indianapolis Museum of Art, Indiana: 34. Magnum / Erich Lessing Collection: 122. Manchester Art Gallery, Manchester: 64a. Mary Evans Picture Library: 106. National Archives, Kew: 115a. National Gallery, London: 28a, 120. National Gallery Archives, London: 114–115. National Gallery of Art, Washington, DC: 46–47. National Gallery of Scotland, Edinburgh: 39. National Portrait Gallery, London: 16a, 55, 93, 97. Private collections: 16b, 20b, 26b, 31, 37, 44b, 58a, 61, 67b, 103b. Réunion des Musées Nationaux, Paris: 80a, 123b, 126–127. Royal Academy, London: back cover, 13, 17, 19, 32, 35a, 35b, 50, 59, 110. Salford Museum & Art Gallery, Salford: 38a. Sheffield Galleries & Museums Trust, Sheffield: 128. Sterling and Francine Clark Art Institute, Massachusetts: 101. Tabley House, University of Manchester: 38b. Tokyo Fuji Art Museum, Tokyo: 36, 53. Toledo Museum of Art, Ohio: 30a. V&A Images / Victoria & Albert Museum, London 26a.
© The National Trust Photo Library: 41.
© Tate, London 2004: 1, 2–3, 4–5, 6–7, 8–9, 12, 14, 16c, 18, 21, 25a, 25b, 28b, 29, 30b, 33a, 33b, 42a, 42b, 43a, 43b, 52, 54, 54–55, 56, 58b, 63, 64b, 65, 68, 69a, 69b, 70, 71, 74a, 74b, 75, 76, 76–77, 78–79, 79, 80b, 81, 84–85, 86, 87, 90, 90–91, 95a, 95b, 104–105, 108, 109, 111, 113a, 113b, 116–117, 118, 119b, 123a, 124a, 124b, 125.

ACKNOWLEDGMENTS

The author wishes to give special thanks to Luke Herrmann, Sylvie Patin and Ian Warrell. Thanks also to Priscilla du Peloux, Laura Valentine at the Royal Academy, Belinda Ross and Rebecca Staffolani at the National Gallery, London, Juliet Cook, Alison Miles and Katie Dobson at the Tate Britain, and to Alice Nègre and Anne Caillat.

Olivier Meslay worked as an art dealer before joining the
Institut National du Patrimoine in France. Since 1993,
he has been a conservator in the department of paintings
at the Louvre, Paris, where he manages the collections of
British, American and Spanish art. He has curated
several exhibitions and has written many articles on the
links between British and French art. He currently
teaches at the École du Louvre.

To my wife, Laure de Margerie.

Translated from the French by Ruth Sharman

Library of Congress Cataloging-in-Publication Data

Meslay, Olivier.
[Turner. English]
Turner : life and landscape / Olivier Meslay.
p. cm. - (Discoveries)
Includes bibliographical references and index.
ISBN 0–8109–9211–6 (pbk. : alk. Paper) 1. Turner, J. M. W. (Joseph Mallord
William), 1775–1851. 2. Painters—England—Biography. I. Title: Life and
landscape. II. Turner, J. M. W. (Joseph Mallord William), 1775–1851. III. Title.
IV. Series: Discoveries (New York, N.Y.)

ND497.T8M4713 2005
759.2–dc22

2005001186

Printed and bound in Editoriale Lloyd, Trieste

10 9 8 7 6 5 4 3 2 1